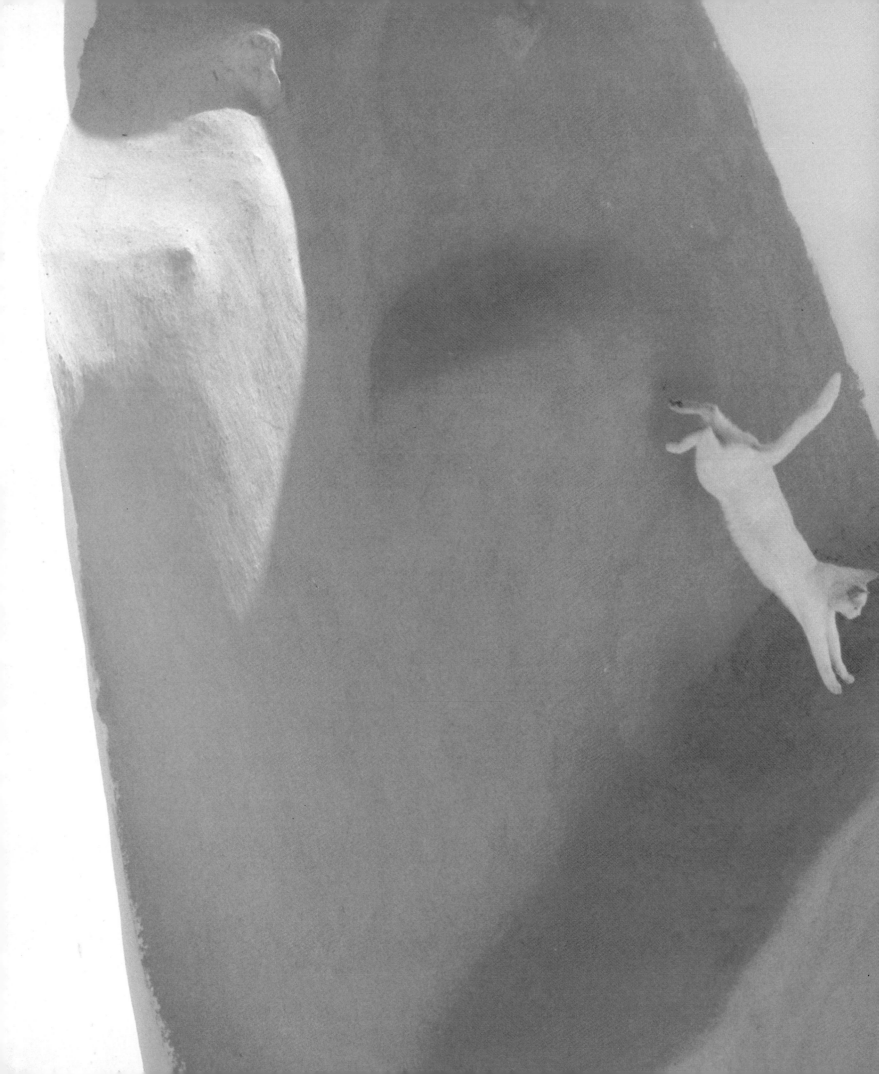

Asleep·in·the·Sun

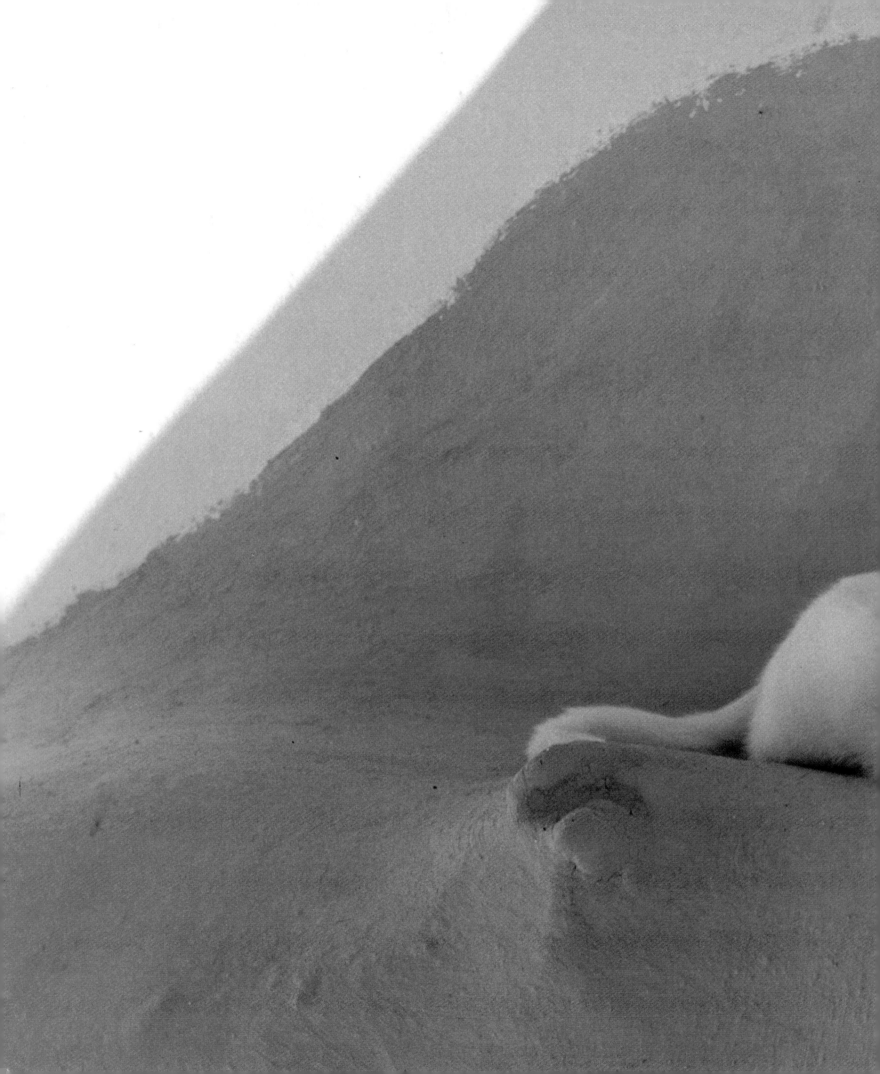

Asleep·in·the·Sun

HANS SILVESTER

CHRONICLE BOOKS

SAN FRANCISCO

First published in the United States in 1997 by Chronicle Books

Copyright © 1997 by Editions de la Martinière
Translation copyright © 1997 by Chronicle Books

Library of Congress Cataloging-in-Publication Data Available.

ISBN 0-8118-1873-X

Printed in France

Jacket design by Caroline McEver

Distributed in Canada by Raincoast Books
8680 Cambie Street
Vancouver, B.C. V6P 6M9

10 9 8 7 6 5 4 3

Chronicle Books
85 Second Street
San Francisco, CA 94105

www.chronbooks.com

Introduction

Humans' relationships with domestic animals have changed incredibly over the years, and only two kinds of animals, dogs and cats, have risen to become our closest friends. In wealthy countries, nearly one fifth of the population has a dog or a cat for a pet. The money spent annually for these animals equals the annual budget of some third world countries. It might seem a pure luxury keeping so many cats and dogs, but in our modern world these millions of animals play a very important social role: They bring happiness to many women, men, and children. These four-footed friends are always ready to share the cares and joys of their "masters." For many people, their pets are their only relief from solitude.

Through the companionship of a cat or dog, we humans have a window on a different sort of awareness. Anyone who lives with an animal knows that his or her companion has another notion of time. For the tomcat, time is like the air—without limit. Cats and dogs are never preoccupied with passing time. Their lot in life is good—they have enough food, much affection, plenty of comfort, and good medical care. Each has a life without difficulties.

*A*gainst this backdrop, we travel to the Cyclades, a cluster of Greek Islands in the southern Aegean Sea. These islands lie well within a natural boundary formed by the olive tree. And where the olive tree flourishes, people practice the siesta—a valued pause, a moment of repose anchored in the cultures of the Mediterranean. Daily life comes to a halt during the hours of intense heat; activity resumes only toward darkness.

In the north, the siesta has never figured into daily life. The English and Germans have borrowed the word "siesta" from the Italian, but have given it a negative connotation linked to the notion of far niente (to do nothing). Though northerners are quick to criticize southerners for their seeming laziness, each year a migration comparable to that of birds brings millions to the south seeking the sun. These northerners, always in a hurry, are attracted by the southern way of life and the respite it offers from the discipline of the industrialized north.

*P*art of that way of life is the siesta. More than a mere nap, the true siesta is a time of waking dreams when the spirit roams the domain of the imagination. A good siesta must be a period of perfect relaxation for both the body and the mind without entirely losing consciousness. It is not the profound sleep into which one sinks at night. Instead, it is a semi-somnolence in halftones, a freedom and easiness of the will, a rediscovery of the instinctive life. Time is suspended; the real world is distanced; the being finds itself again, without seeking.

For those who would learn to siesta well, I advise taking a cat as a teacher. For cats, the siesta is a sacred time which under no circumstances should be disturbed. History tells us that the prophet Muhammad cut his burnoose in two so as not to awaken his cat who was asleep on it.

Look closely at a peacefully sleeping cat, the true master of relaxation. A cat lives according to its desires and moods, and it sleeps when it wants, whether in the day or at night. Its forepaws serve as a pillow, its fur is as good as a mattress, and its tail curls around its body to protect it. On the Greek islands, as everywhere else in the world, cats cling to these moments of rest — they are absolutely necessary for them. To siesta alone in an agreeable spot is pleasant; snoozing in pairs or groups increases the pleasure. Add amorousness, and it's paradise on earth for any cat.

The Greek cats of the Cyclades seem able to sleep anywhere — on a concrete slab or carpet, or perched in a tree — but in truth, they are quite particular in their choice of snoozing places. A cat considers whether there's sun or shade, whether to sleep on the ground or aloft, whether to seek shelter from the wind or not. It may change its siesta site ten times a day. Always, it seeks maximum comfort without forsaking safety. Sleeping cats, even when deeply asleep, don't allow themselves to be taken by surprise. At the slightest unfamiliar sound, they come awake with a start. So to photograph cats in repose, it is necessary to win their complete trust. The least uneasiness will cause a change of attitude; the cats' utter relaxation disappears. When Greek cats and humans take their siestas at the same time, the photographer is alone with his feline subjects, who are easily disturbed by someone that does not respect the ritual naptime.

For several years I have nosed into the matter as discreetly as possible. I am an unconditional lover of the siesta, and I often grow jealous while observing cats. I hope that rather than make you jealous, these images will make you want to imitate sleeping

cats—though taking a nap with the same naturalness is not as simple as one might think. Some training and willpower are needed. Learn how to benefit from an afternoon rest, and you will understand that for cats and humans alike the siesta is an art of living.

"Progress" transforms our perception of time. Everything operates faster today than yesterday and, even so, time escapes us. Speed has become a constant objective without our really knowing why. We have forgotten that we remember only the impassioned moments of our lives, those that are interesting, agreeable, or distressing—as René Char said, "The essential is incessantly menaced by the insignificant"—and we suffer the exigencies that we constantly impose on ourselves. In our modern world, having money has become such a necessity that it no longer seems possible to exist without it. None among us escapes the terrible pressure of that reality. We no longer have time to breathe, time to rest with nothing to do, time to dream, to doze—time, in short, to take a siesta. And it is because of this, in large part, that we admire our cats. To live with beings that know neither cares nor human stresses—what repose for the modern human!

Let us admire our friends the cats, yes, but above all, let us learn some of their wisdom: for them, to live and to have time are the same thing.

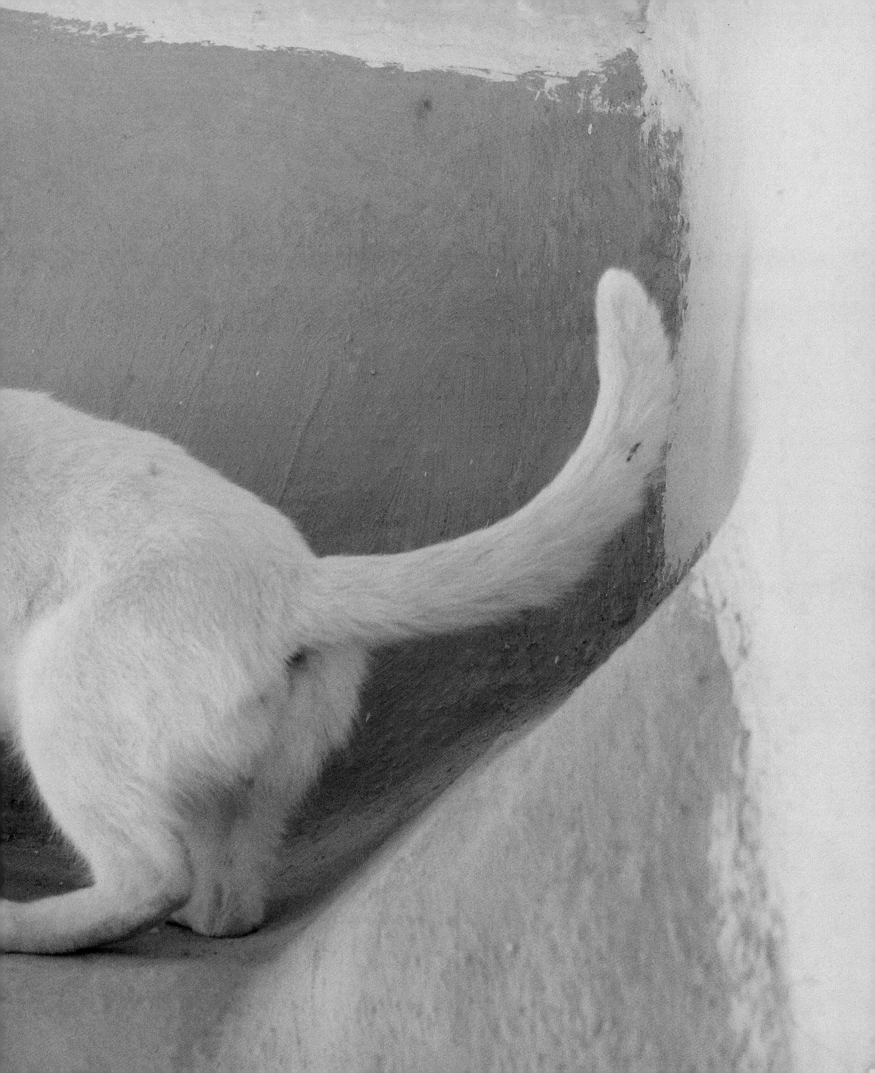

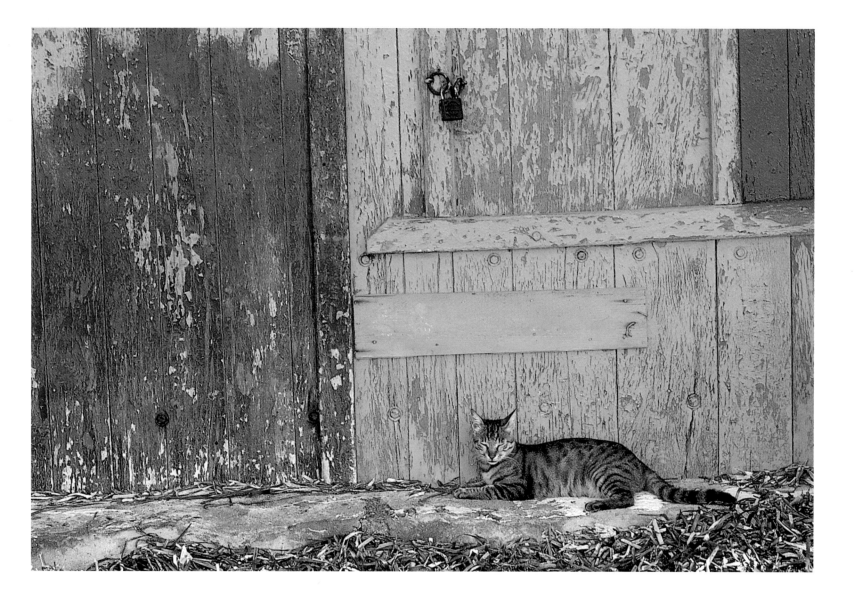

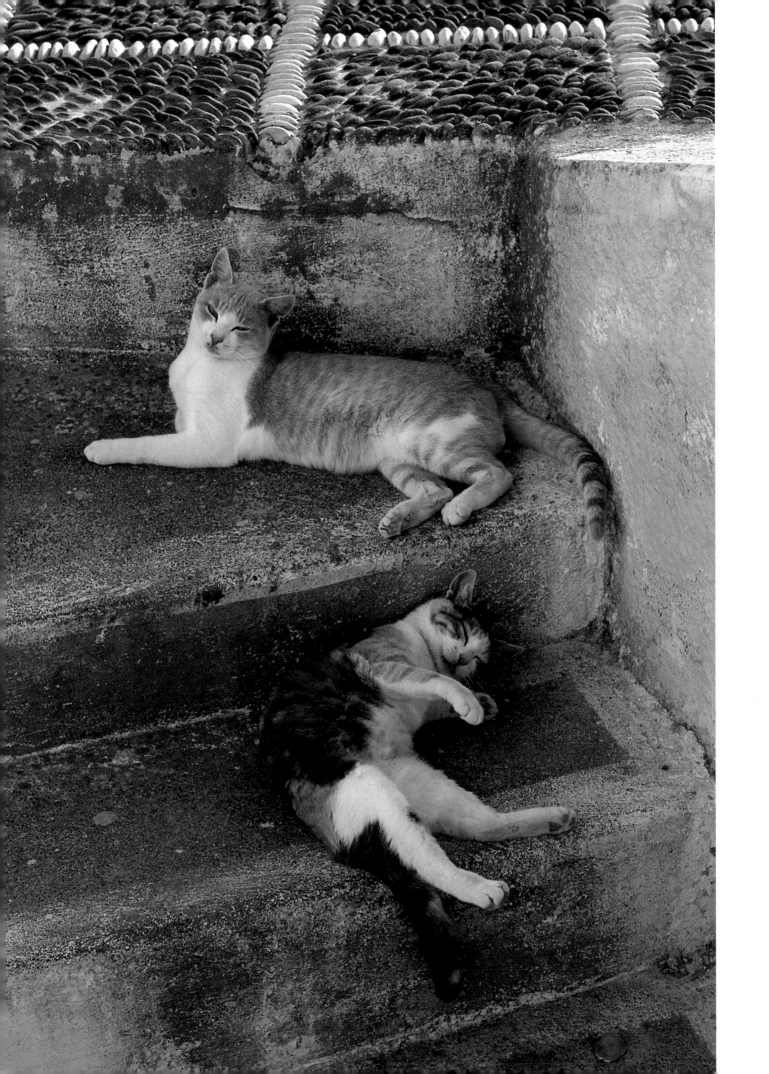

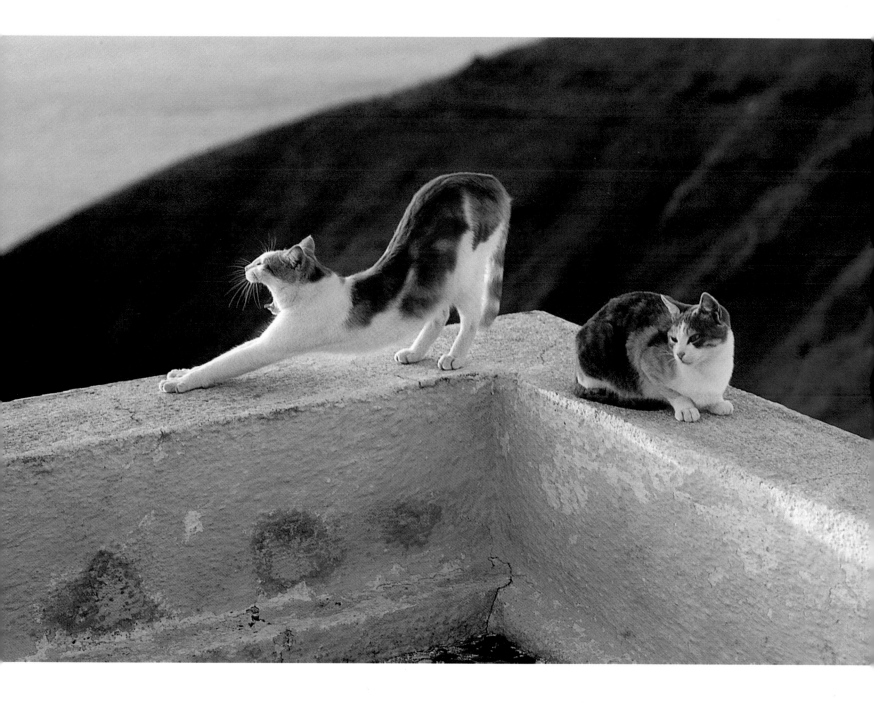

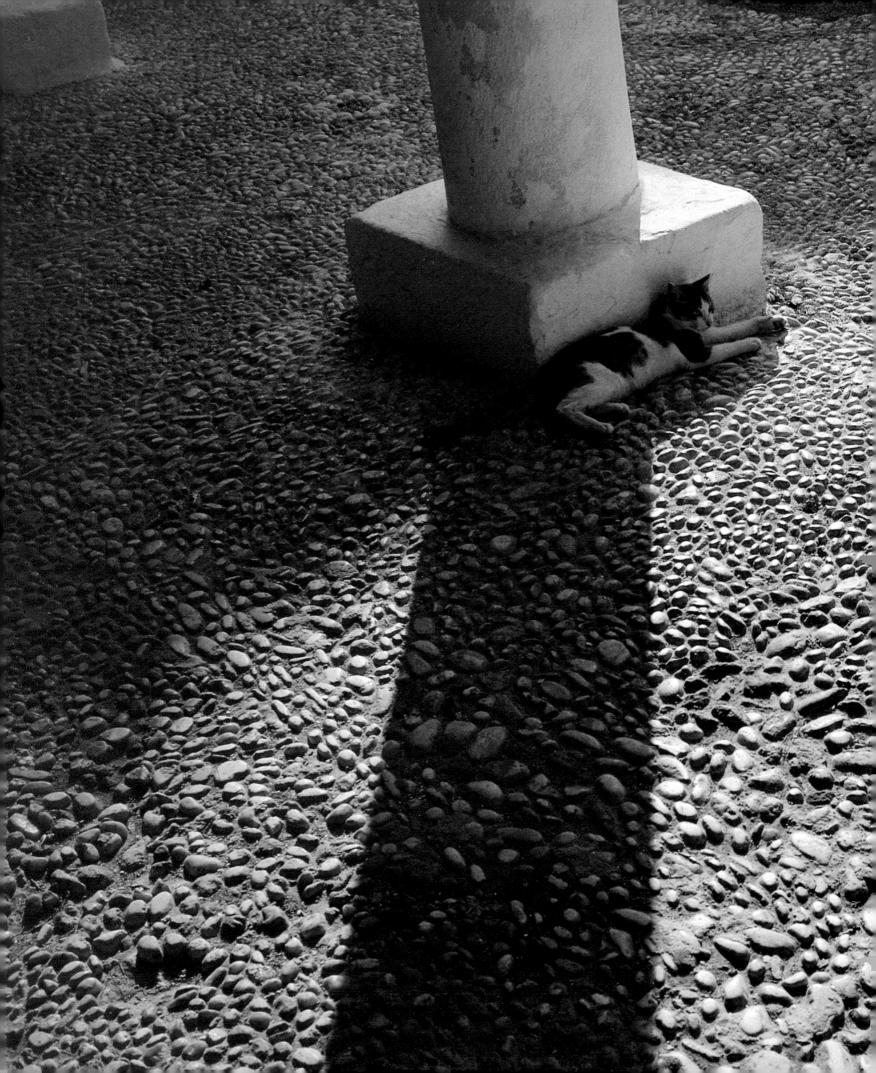

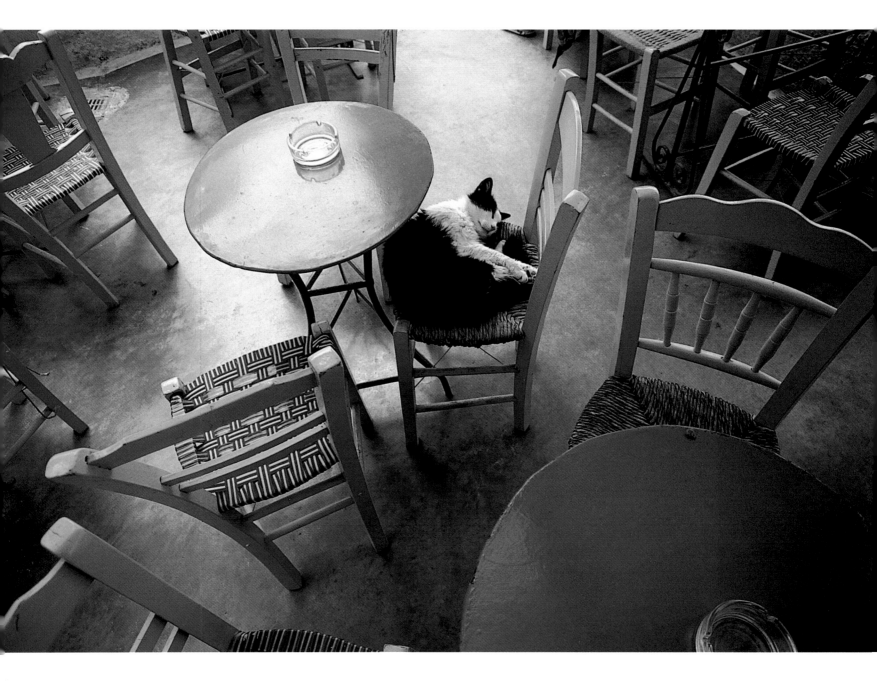

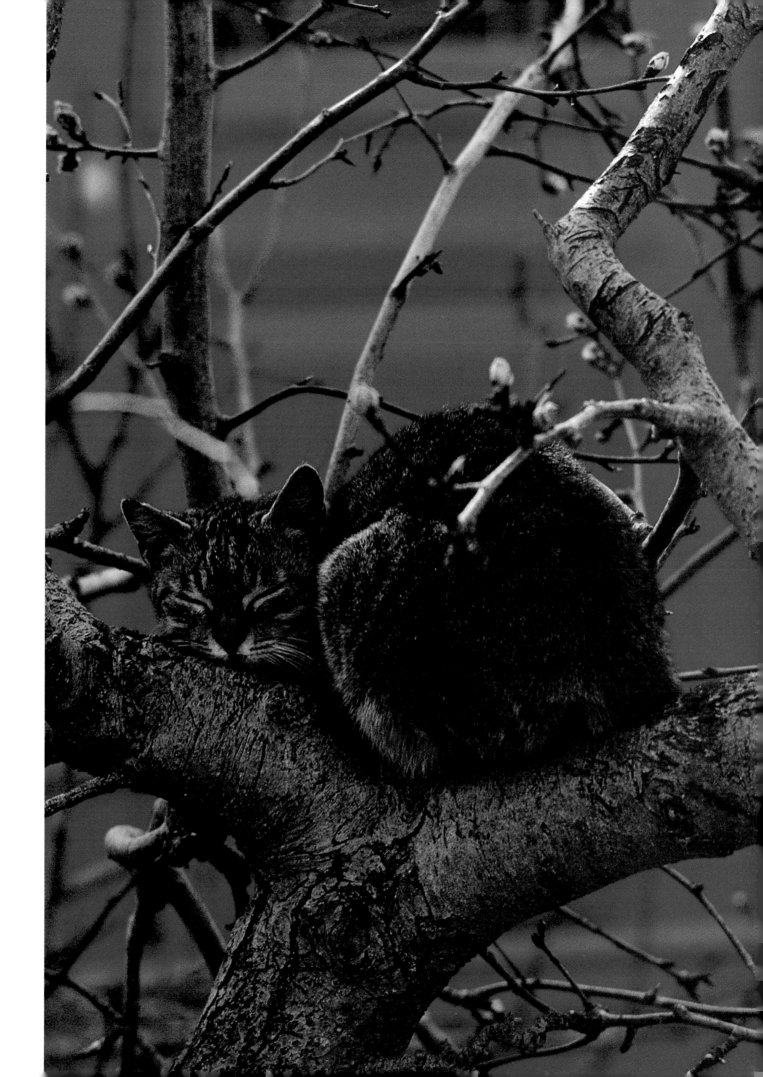

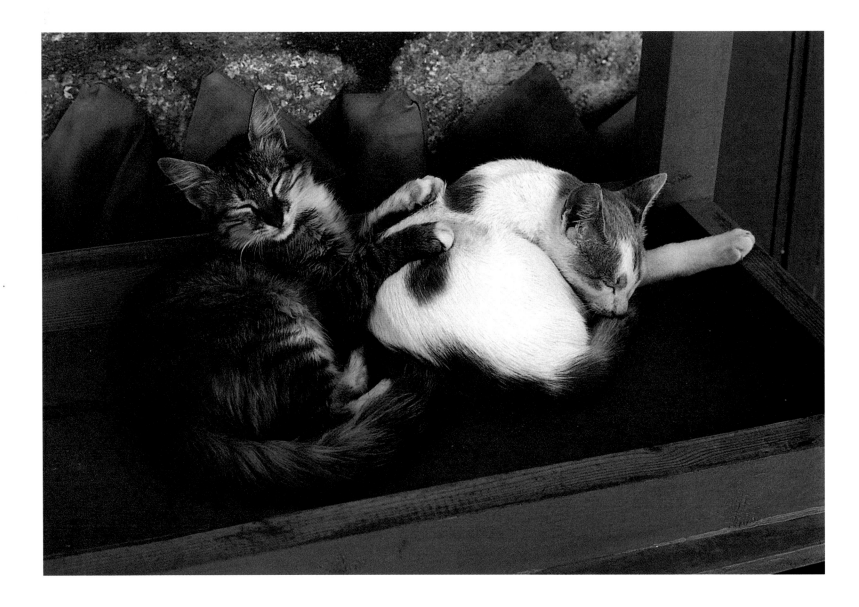

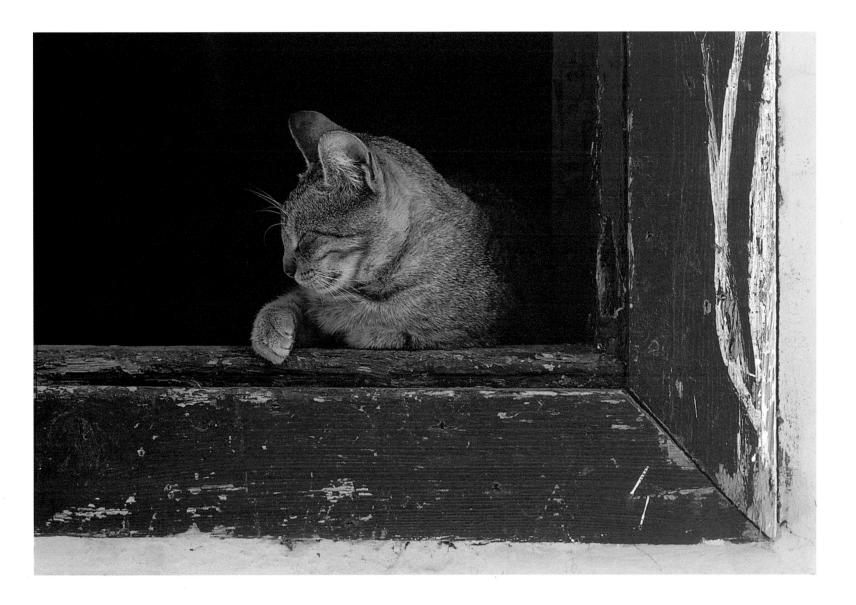

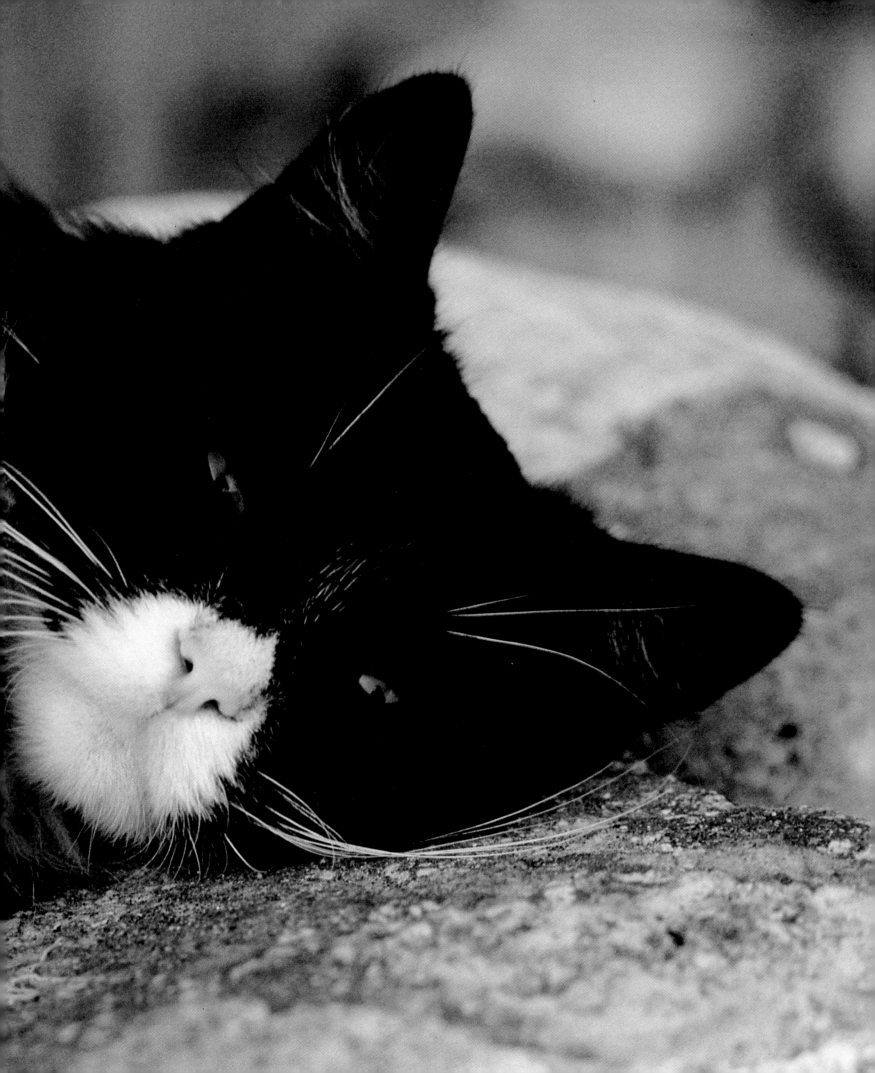

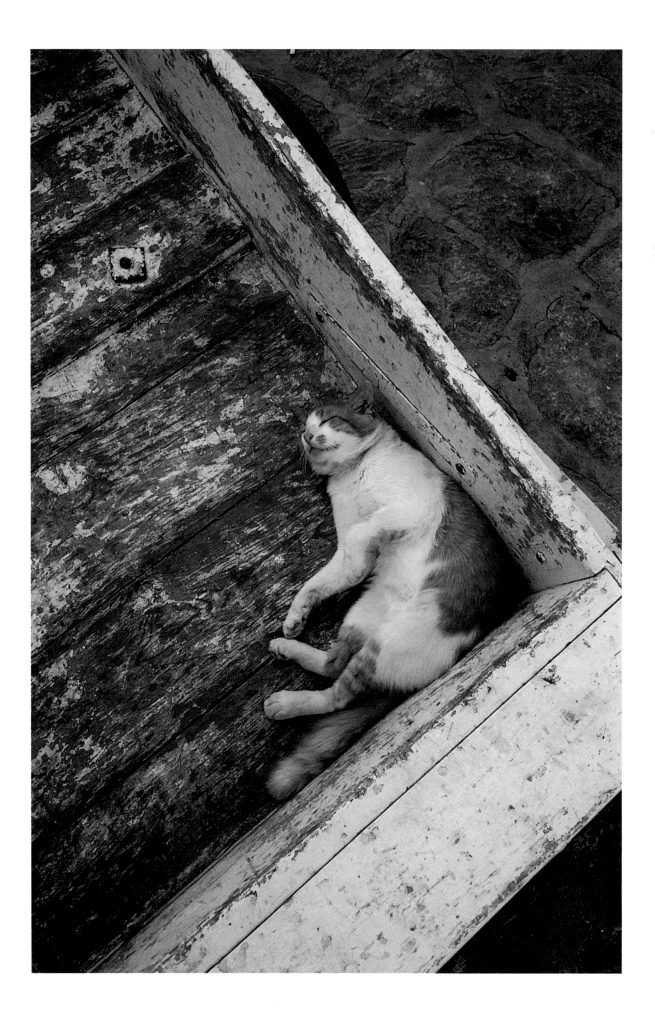

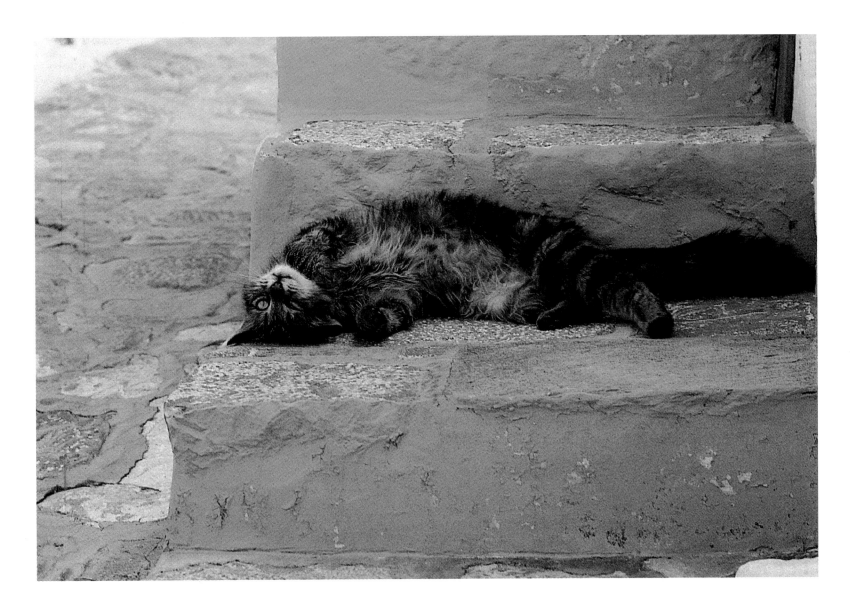

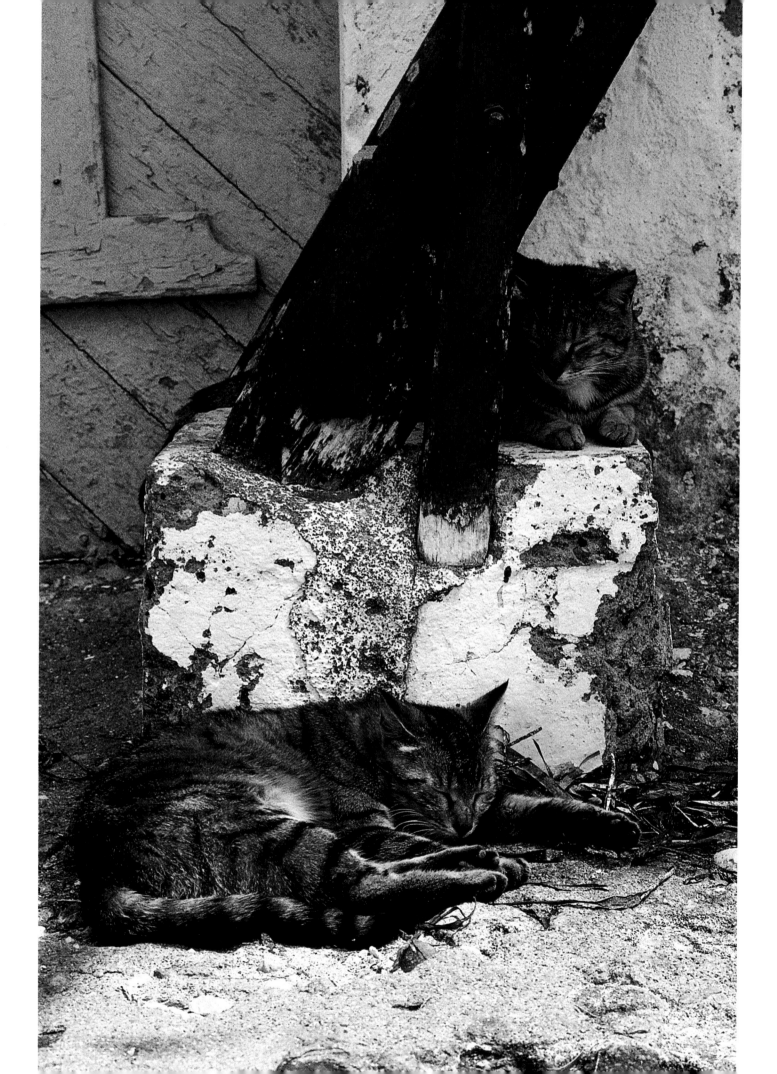

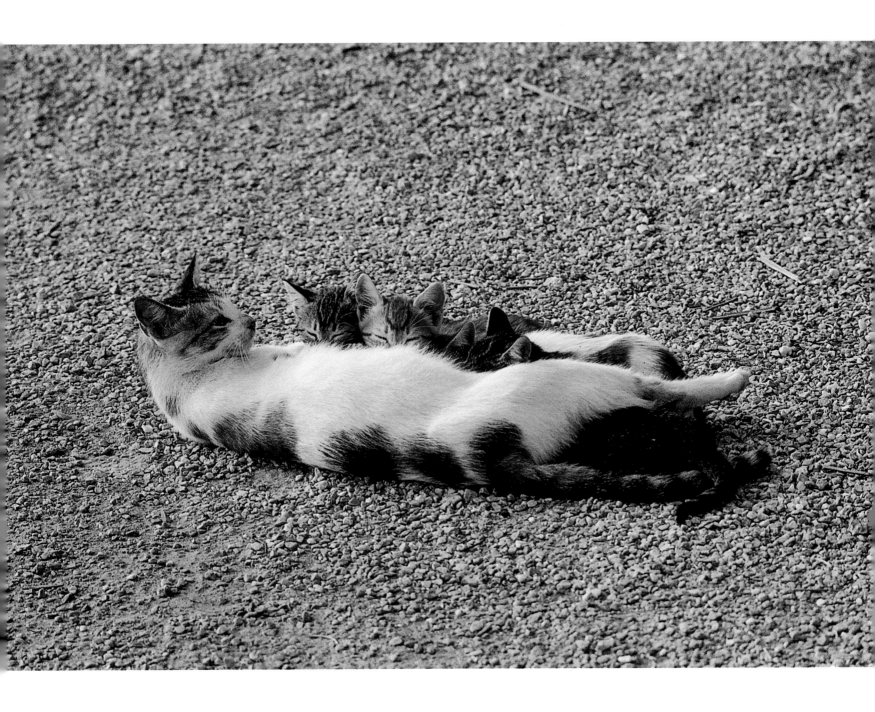

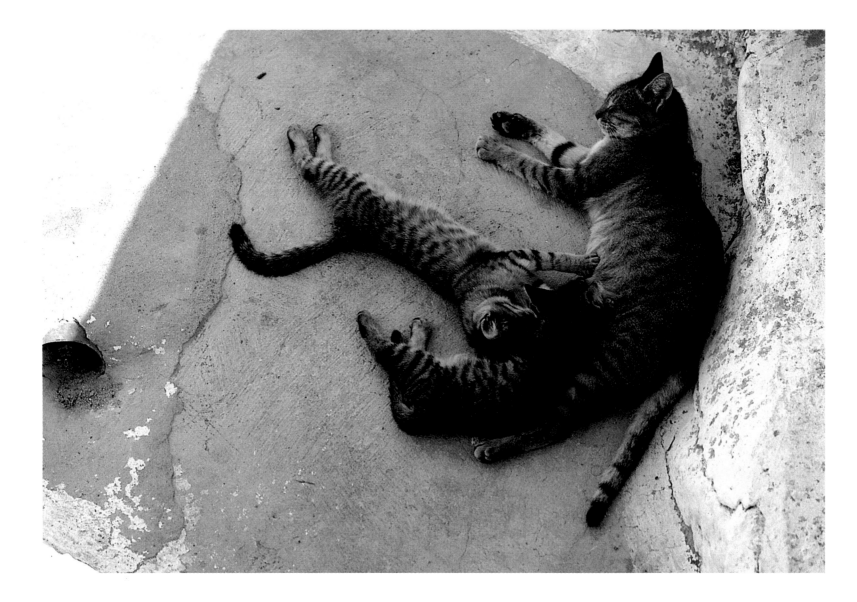

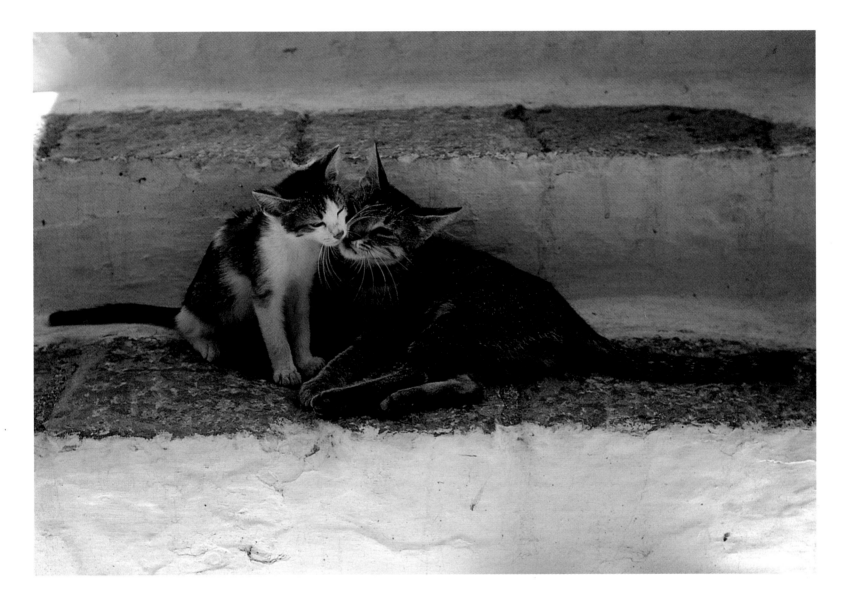

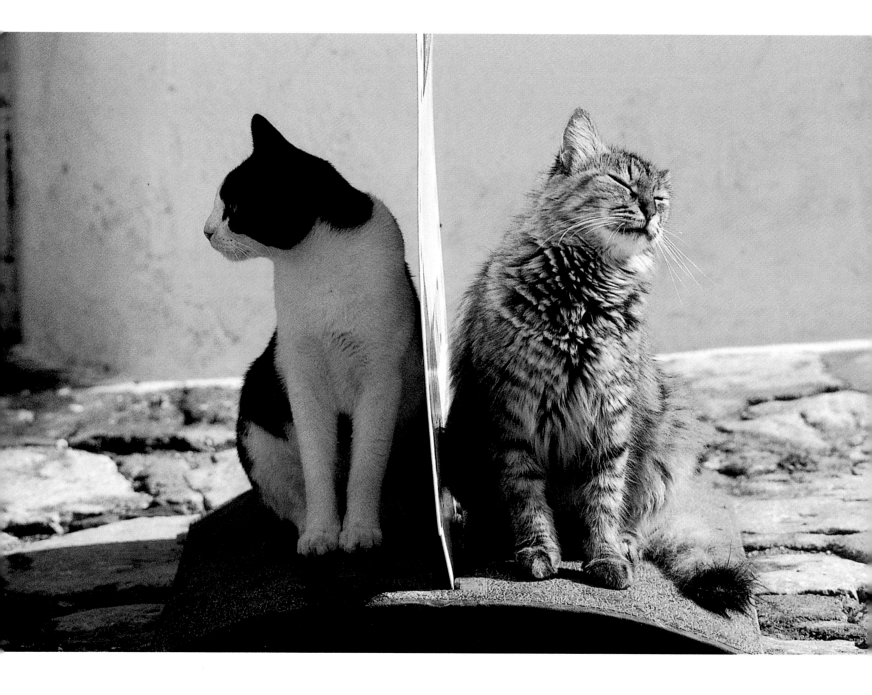

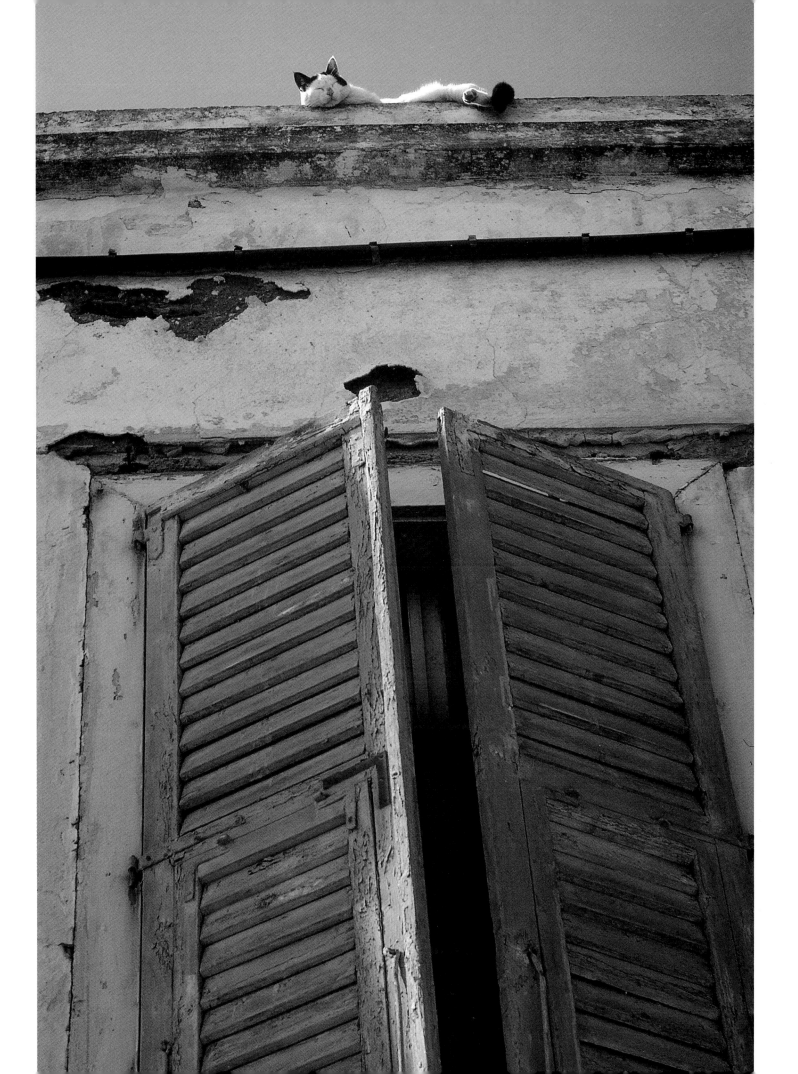

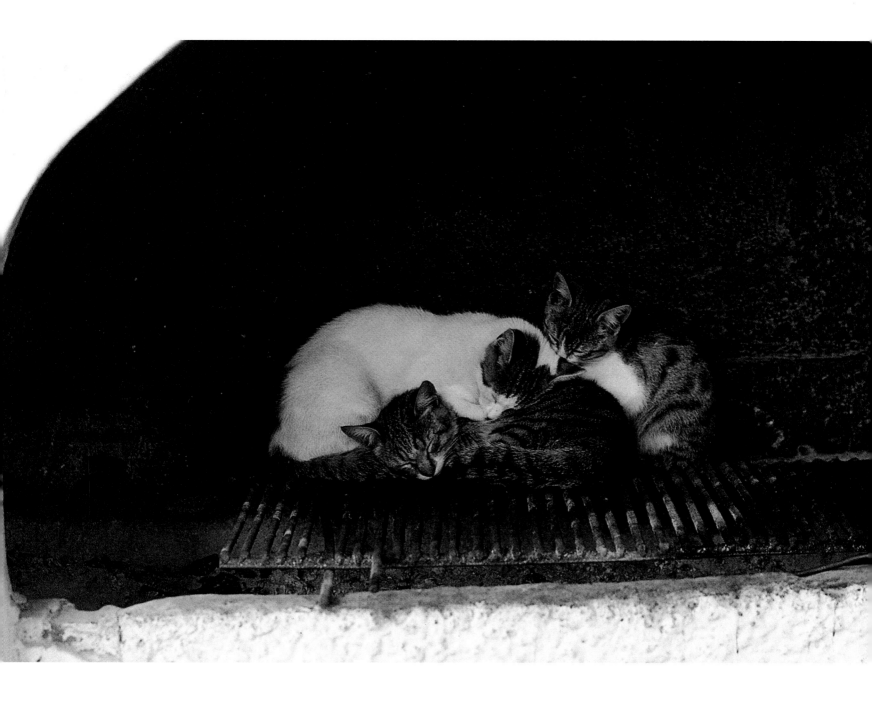

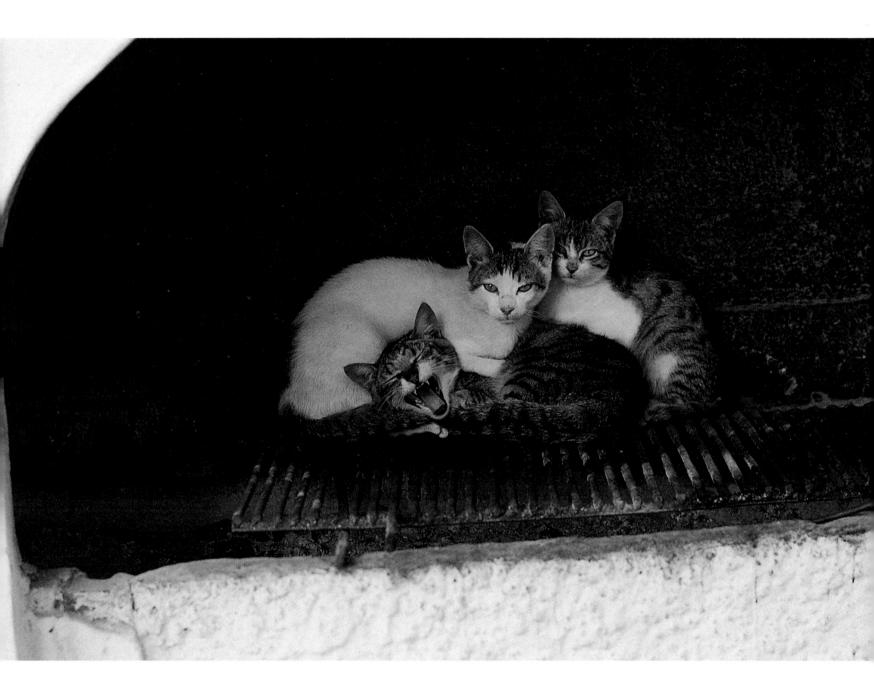

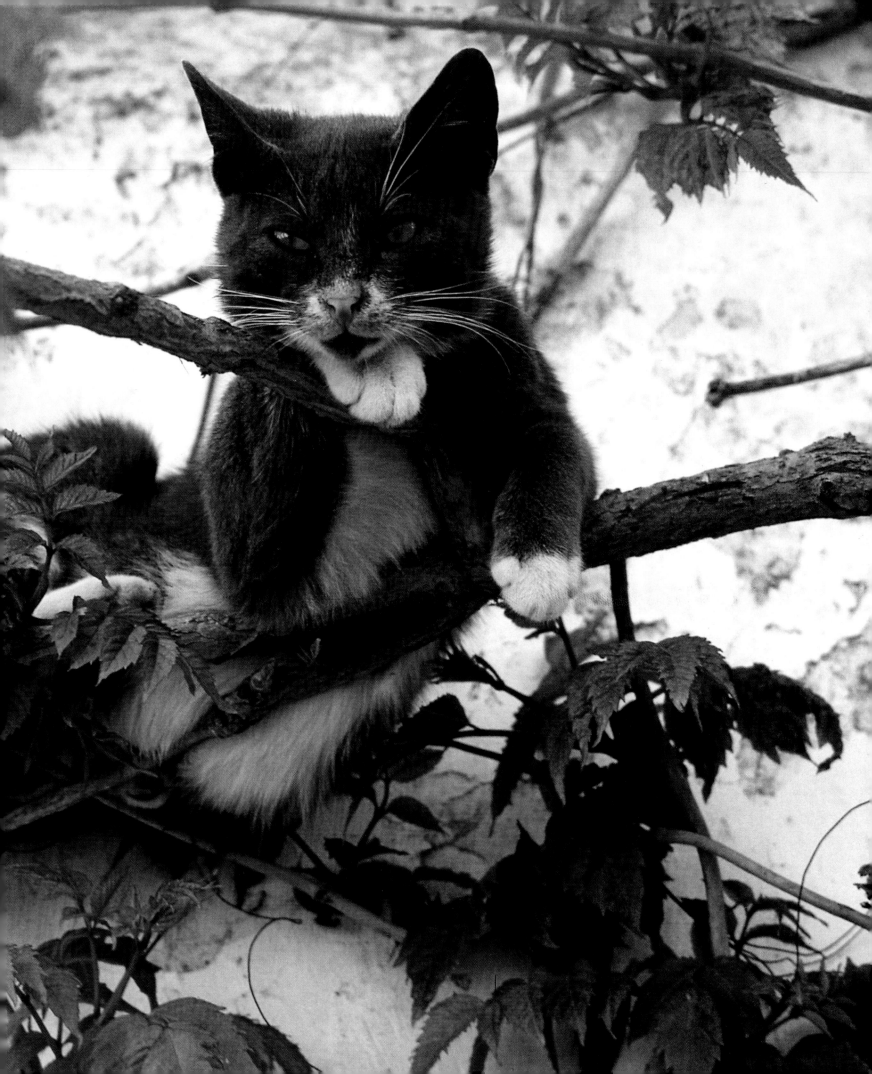

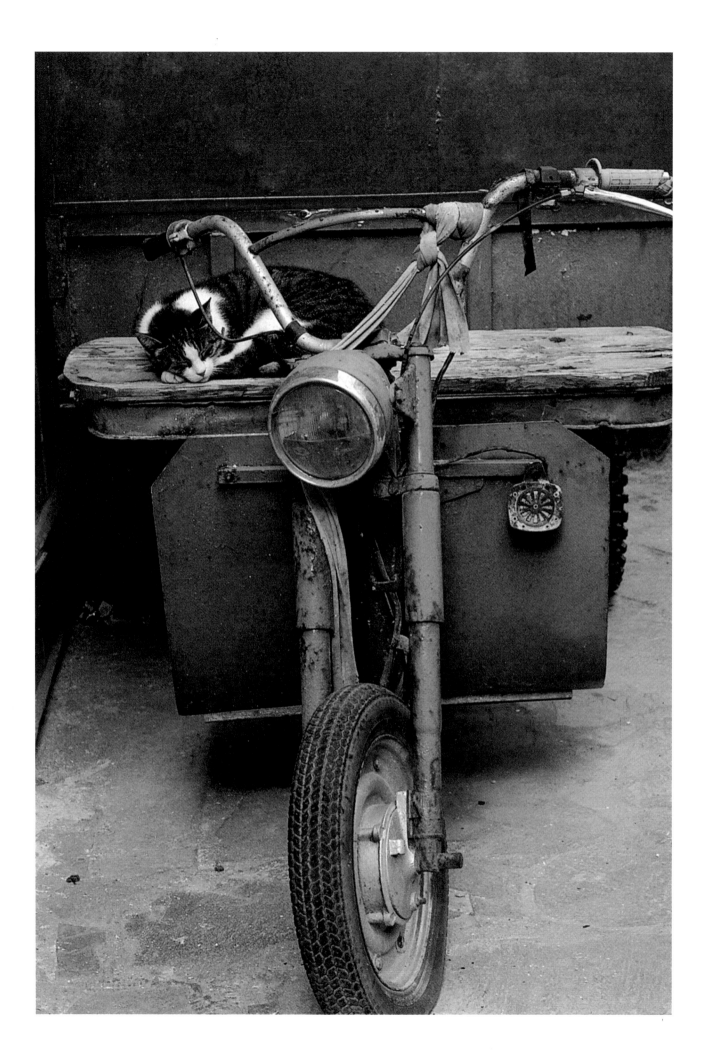

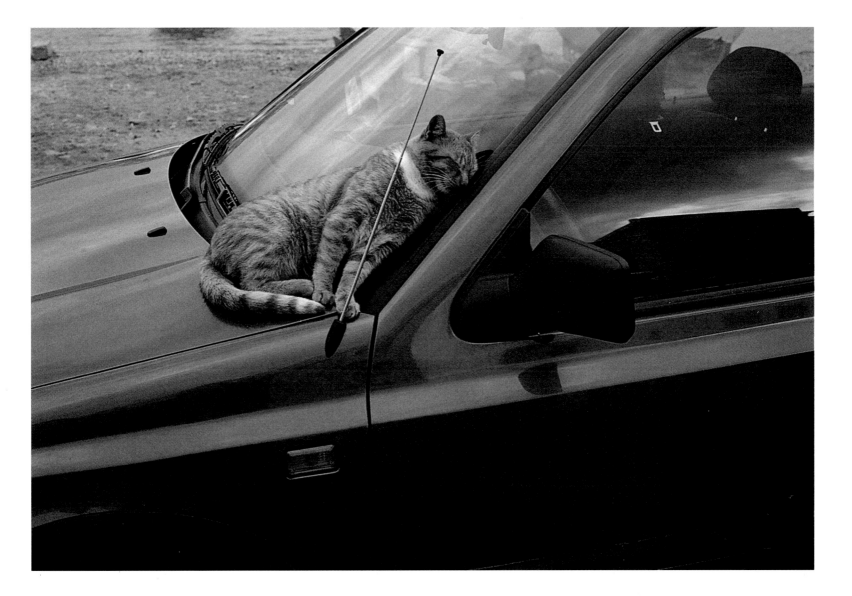

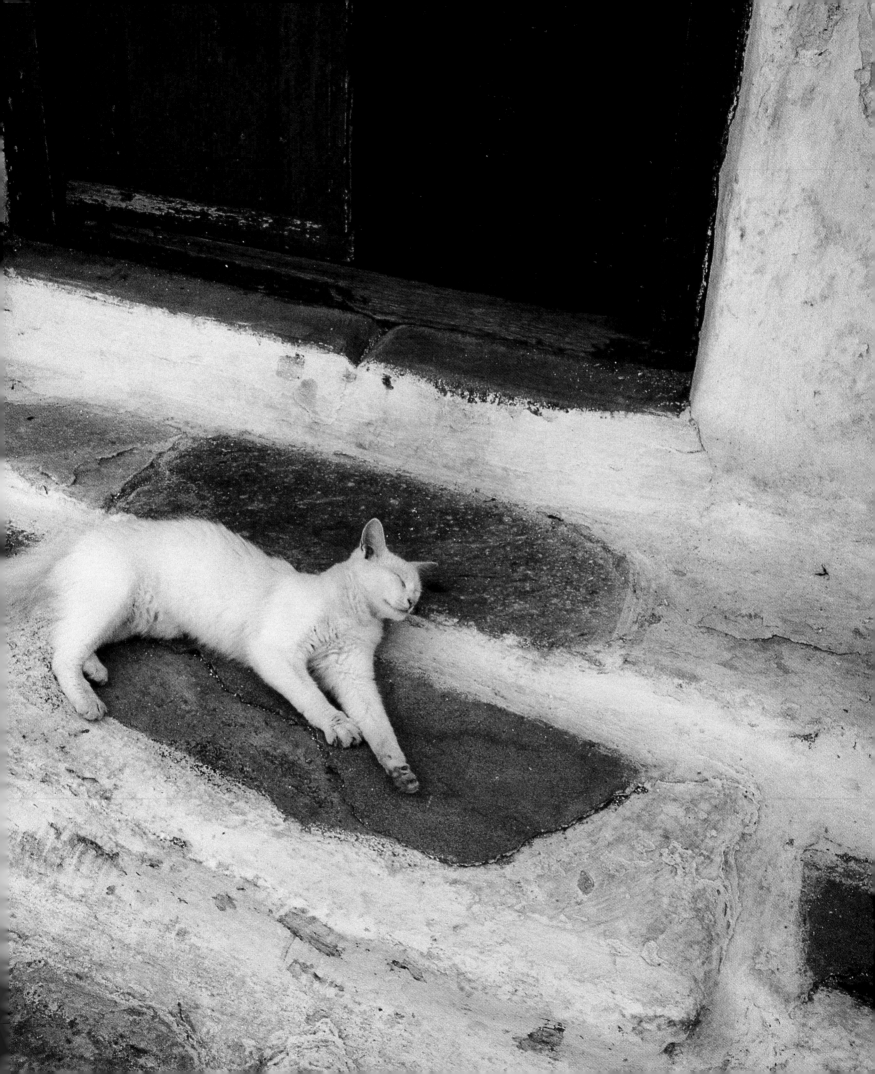

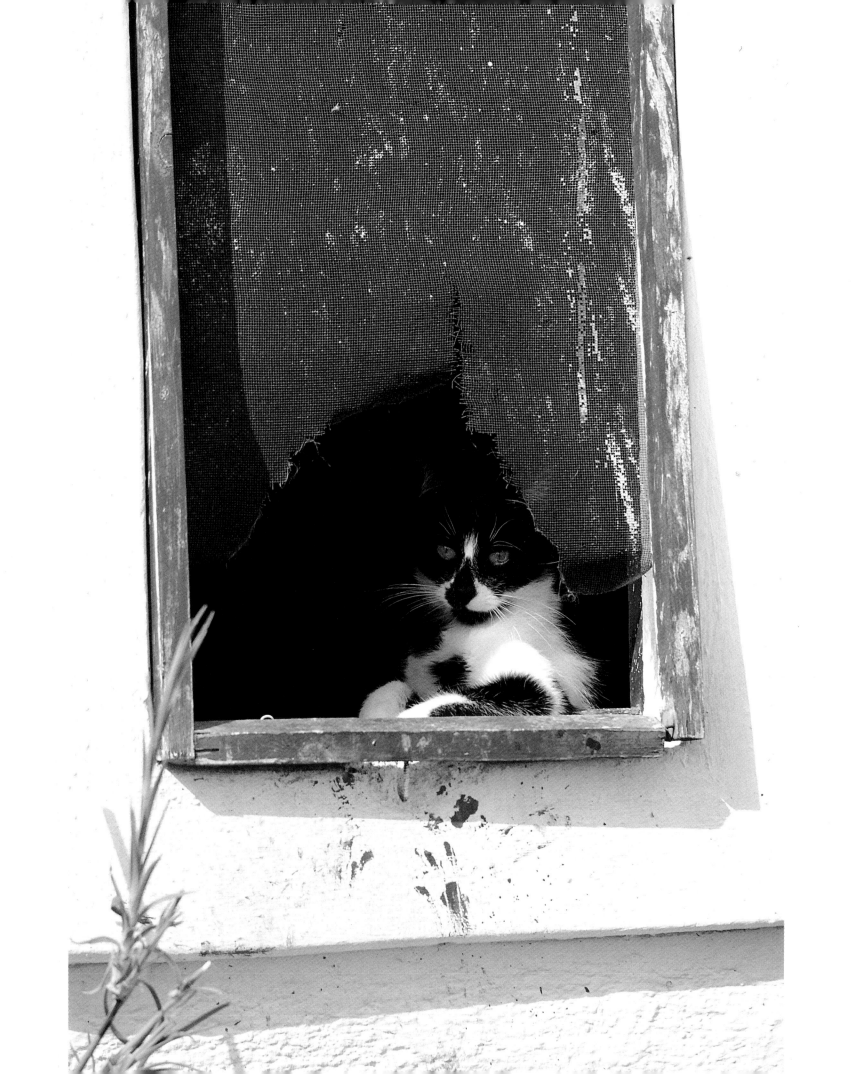

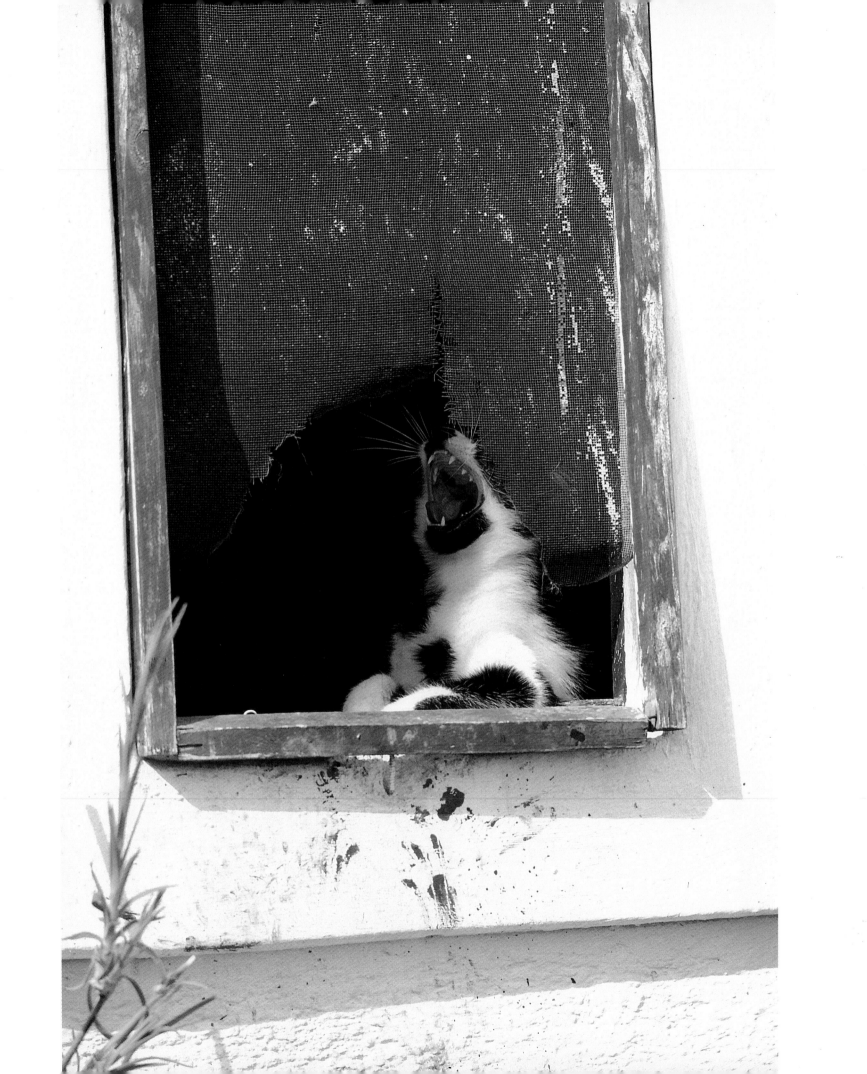

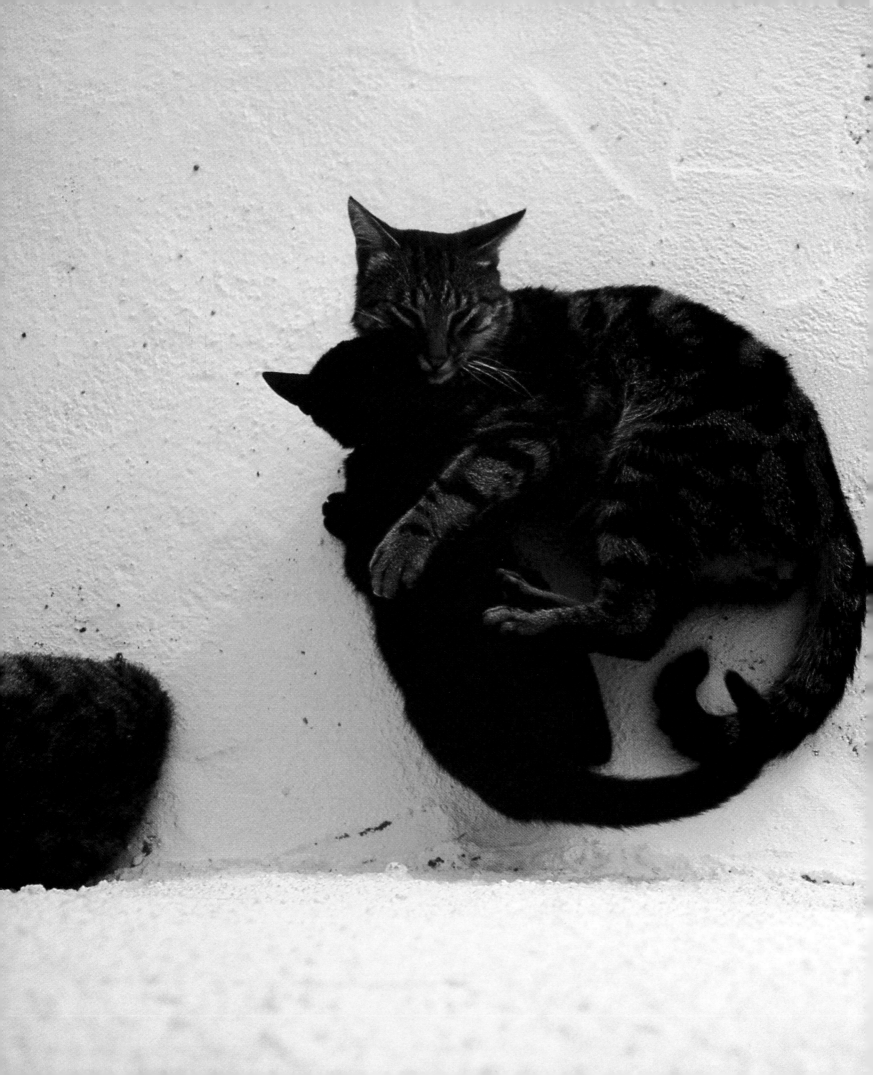

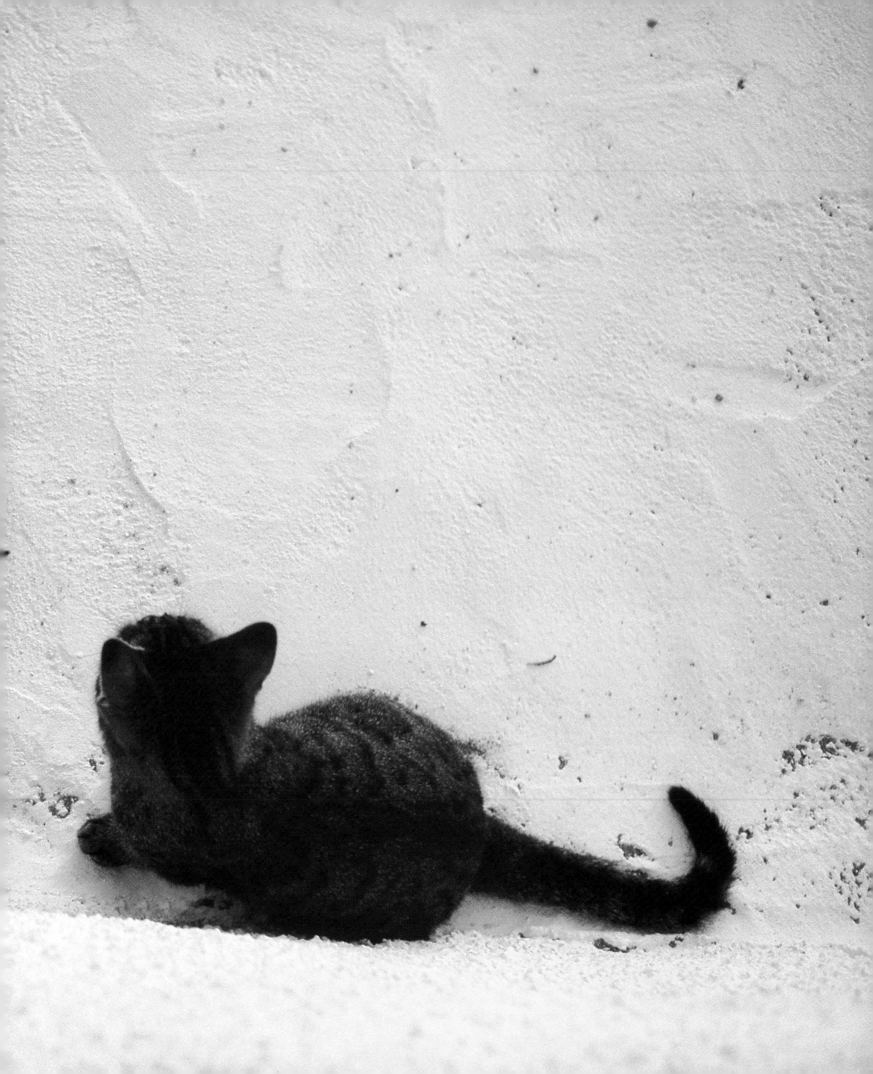

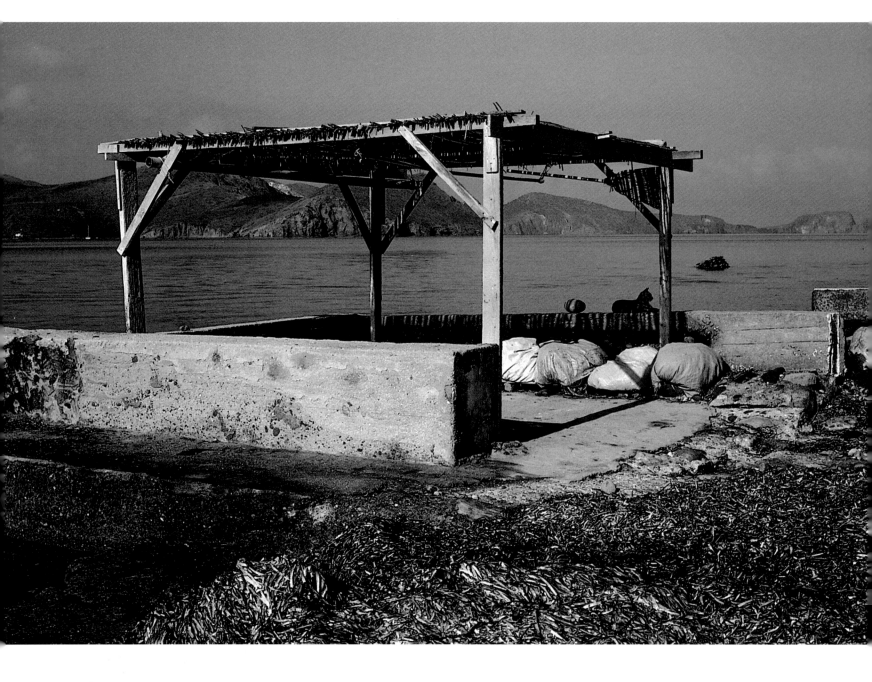

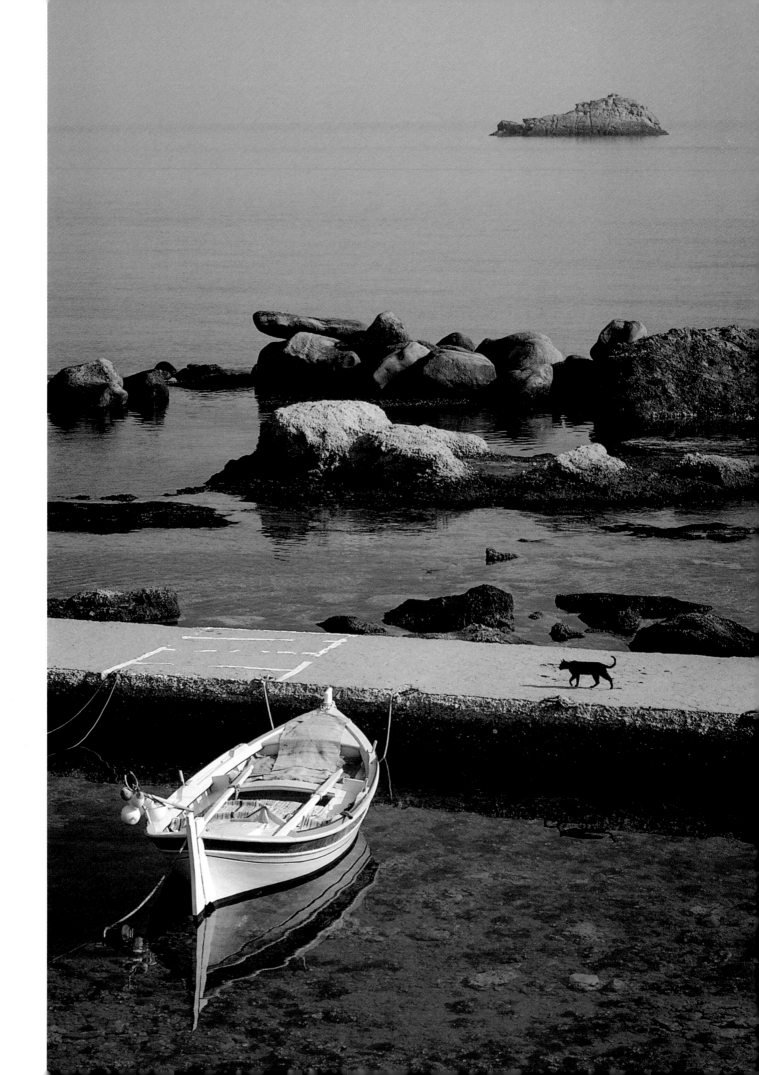

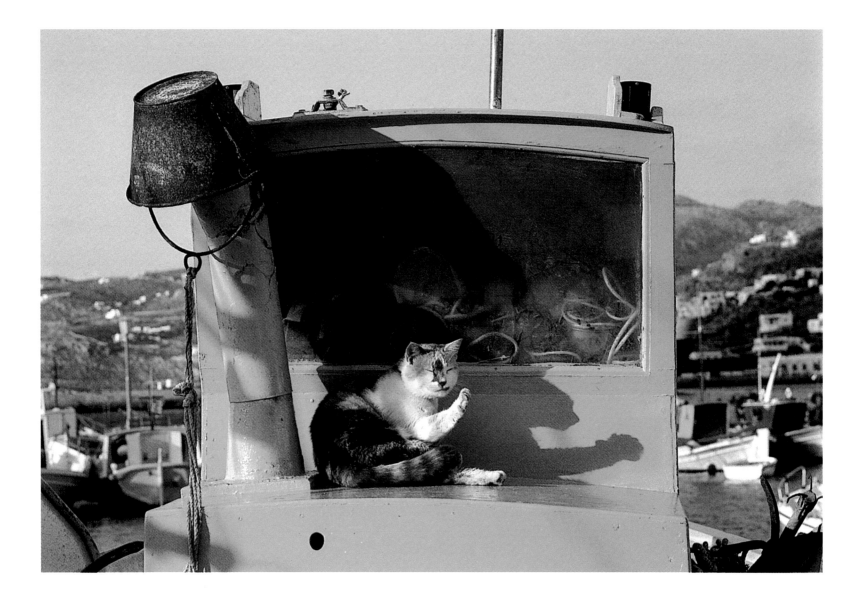

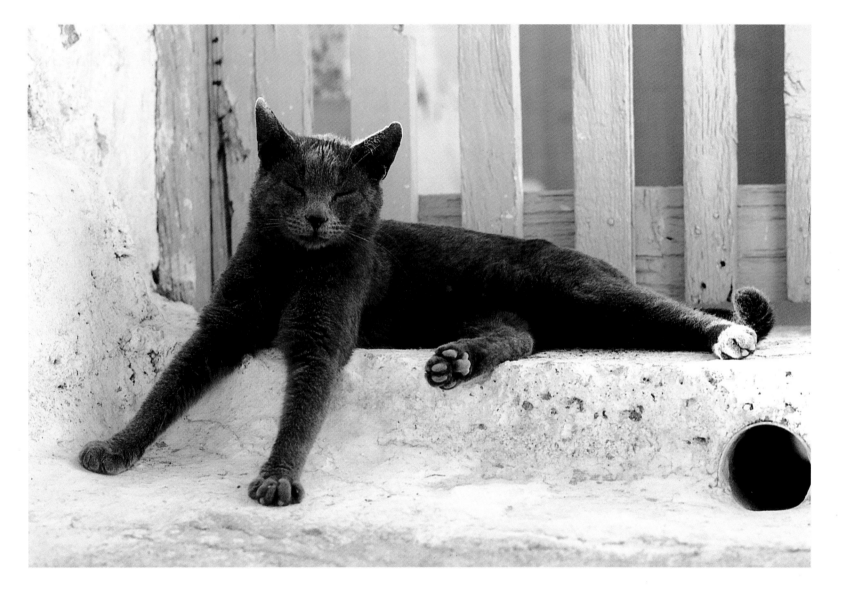

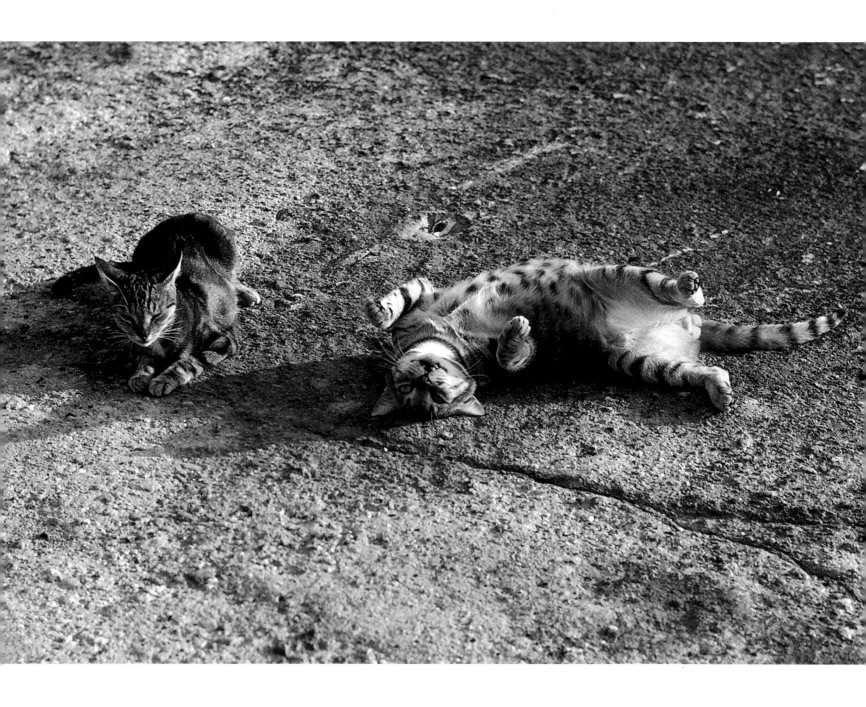

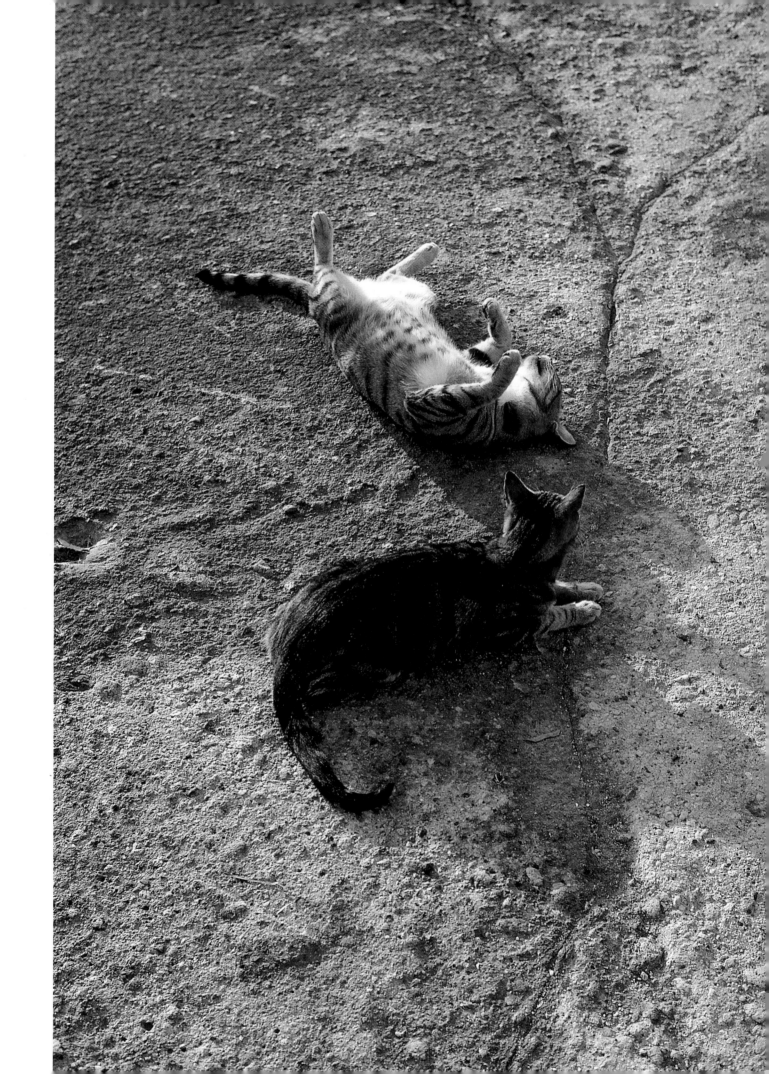

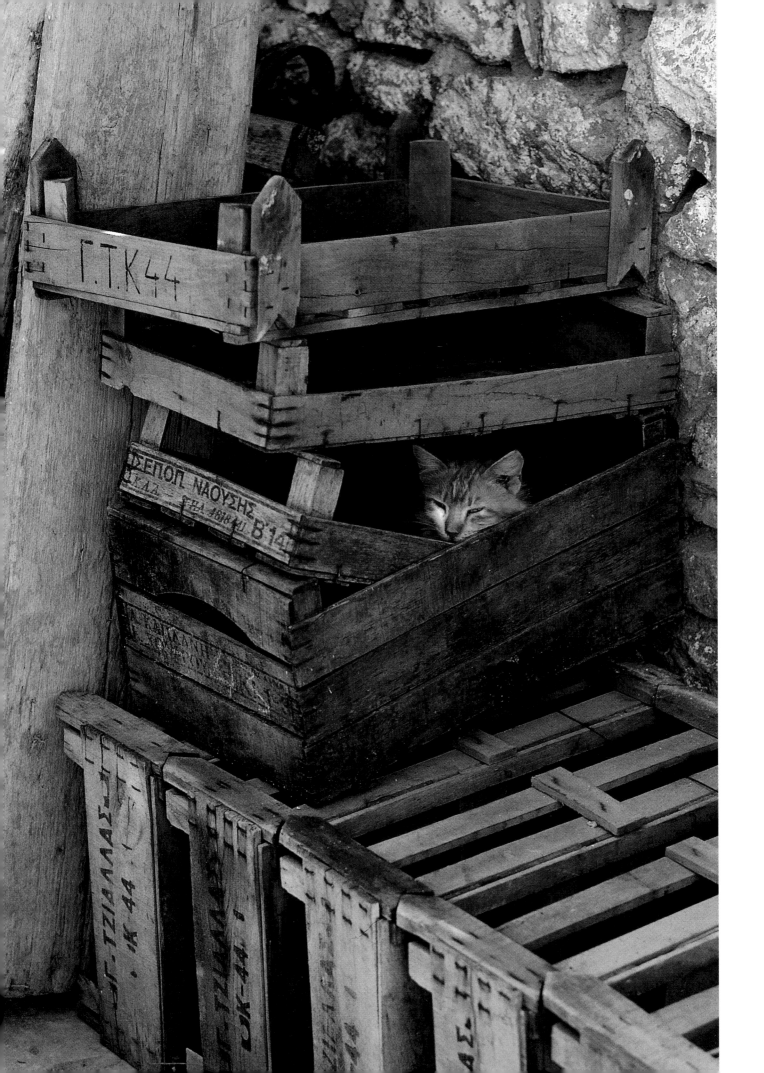

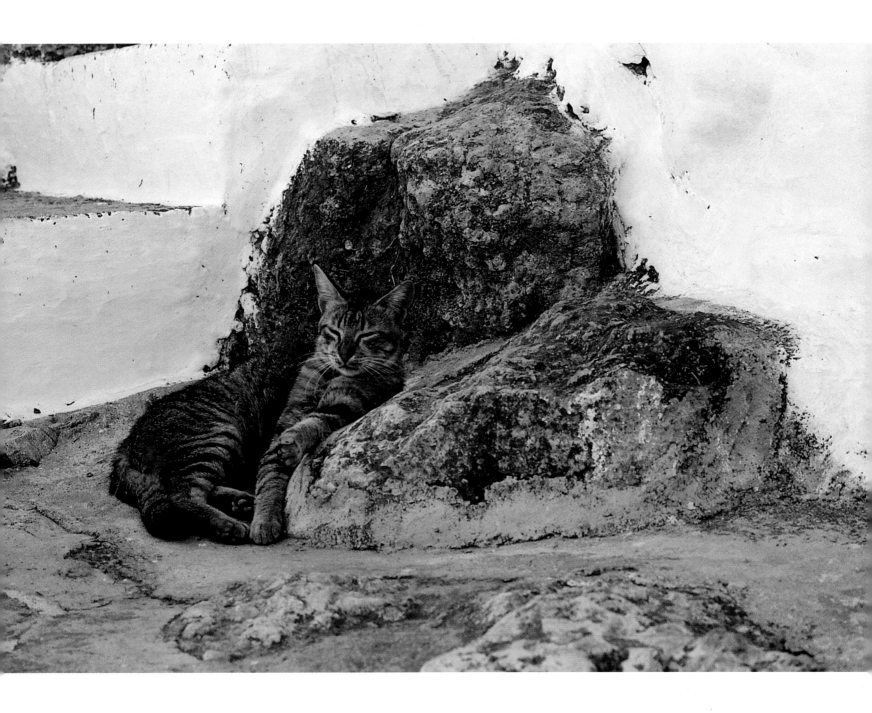

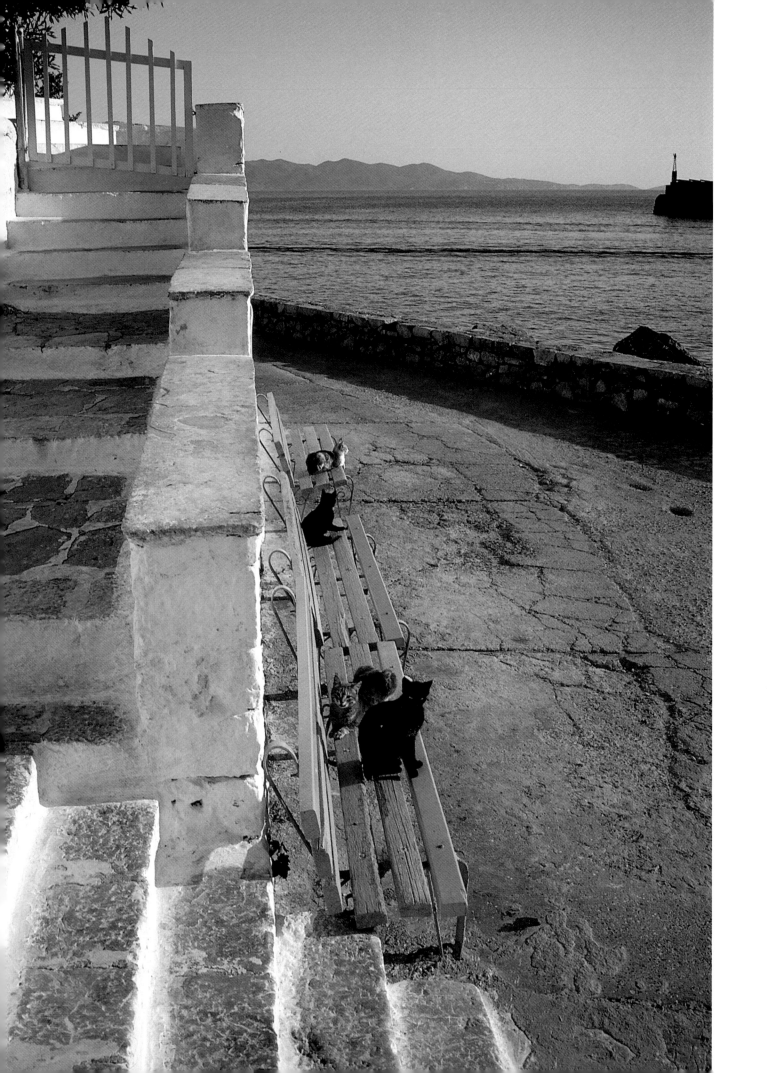

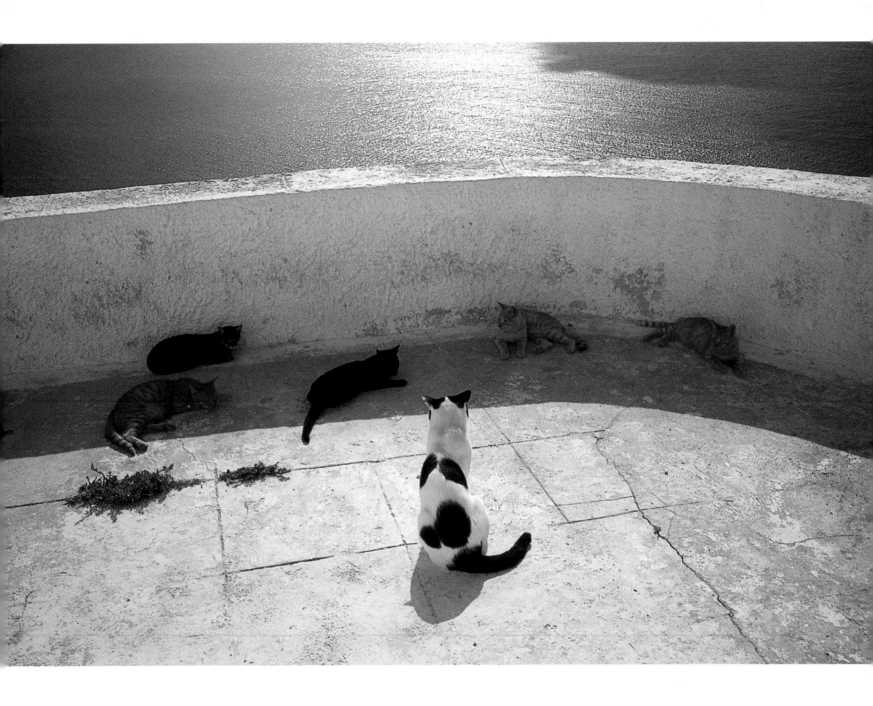

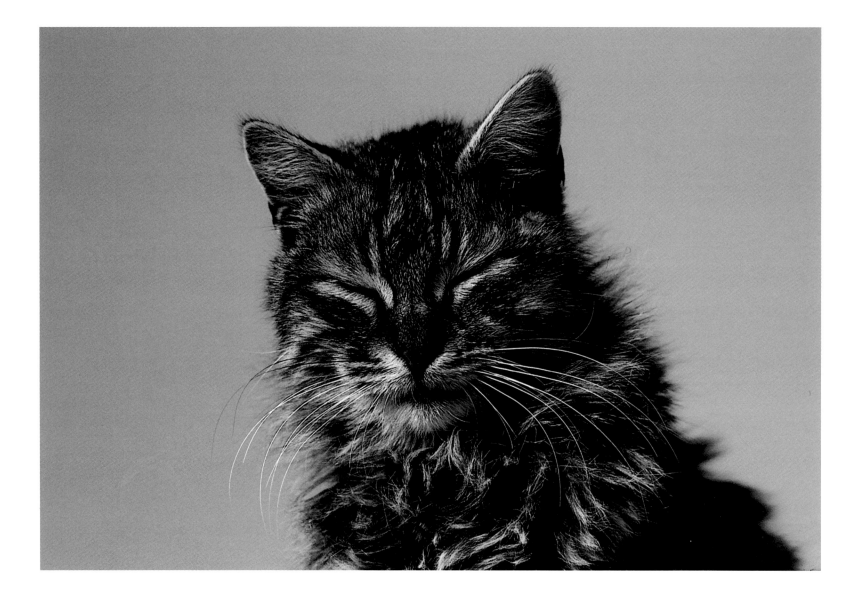

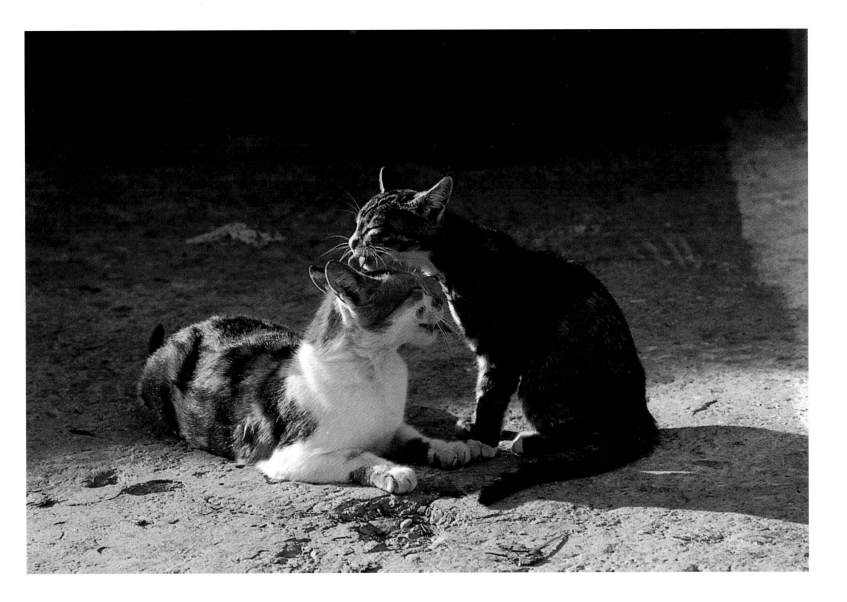

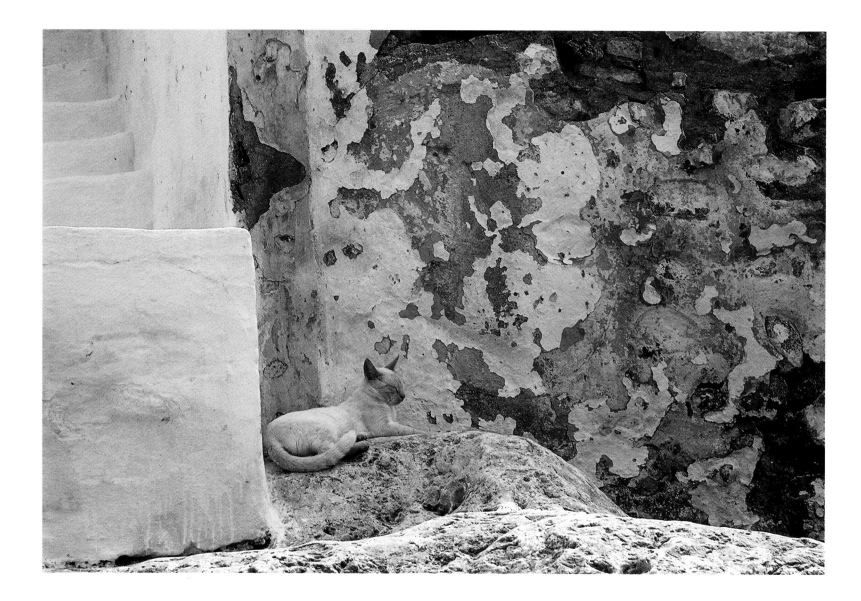

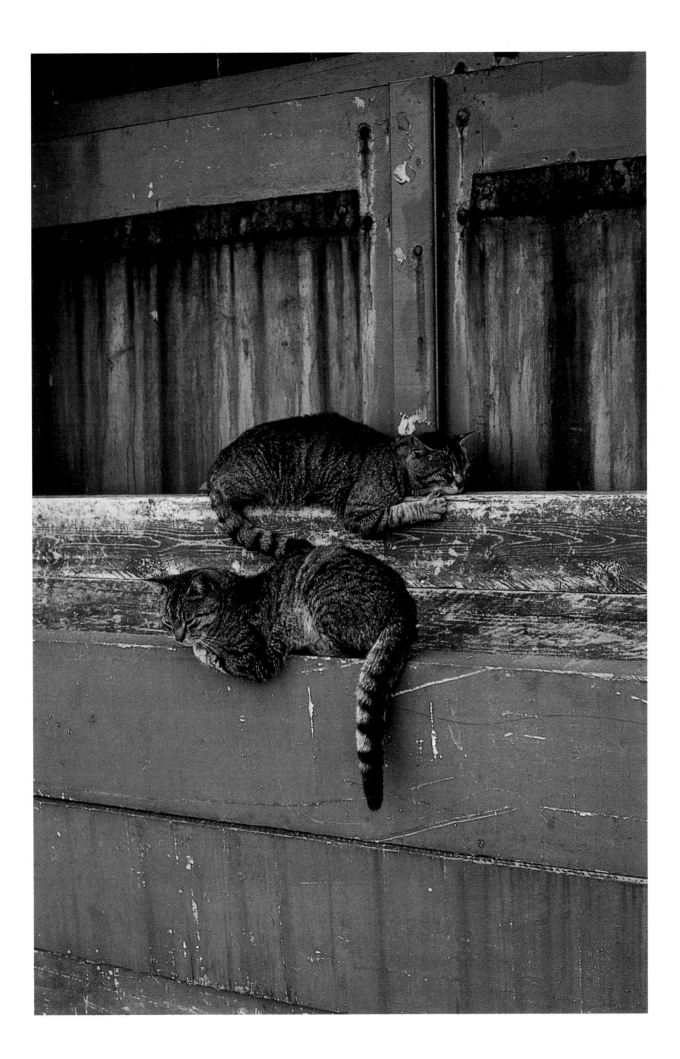

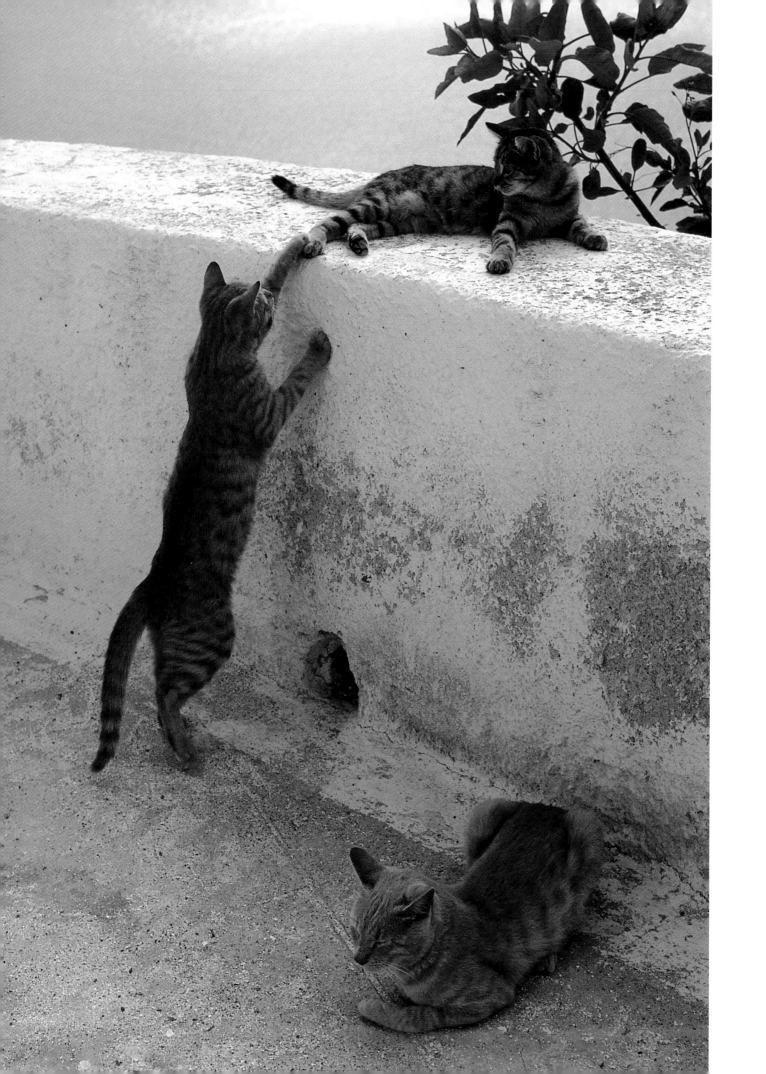

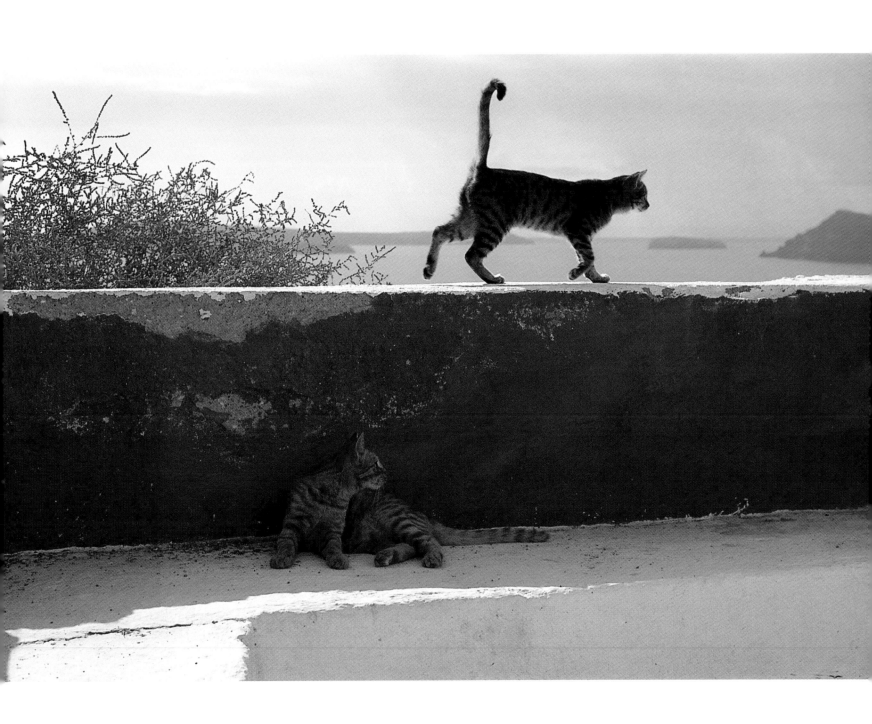

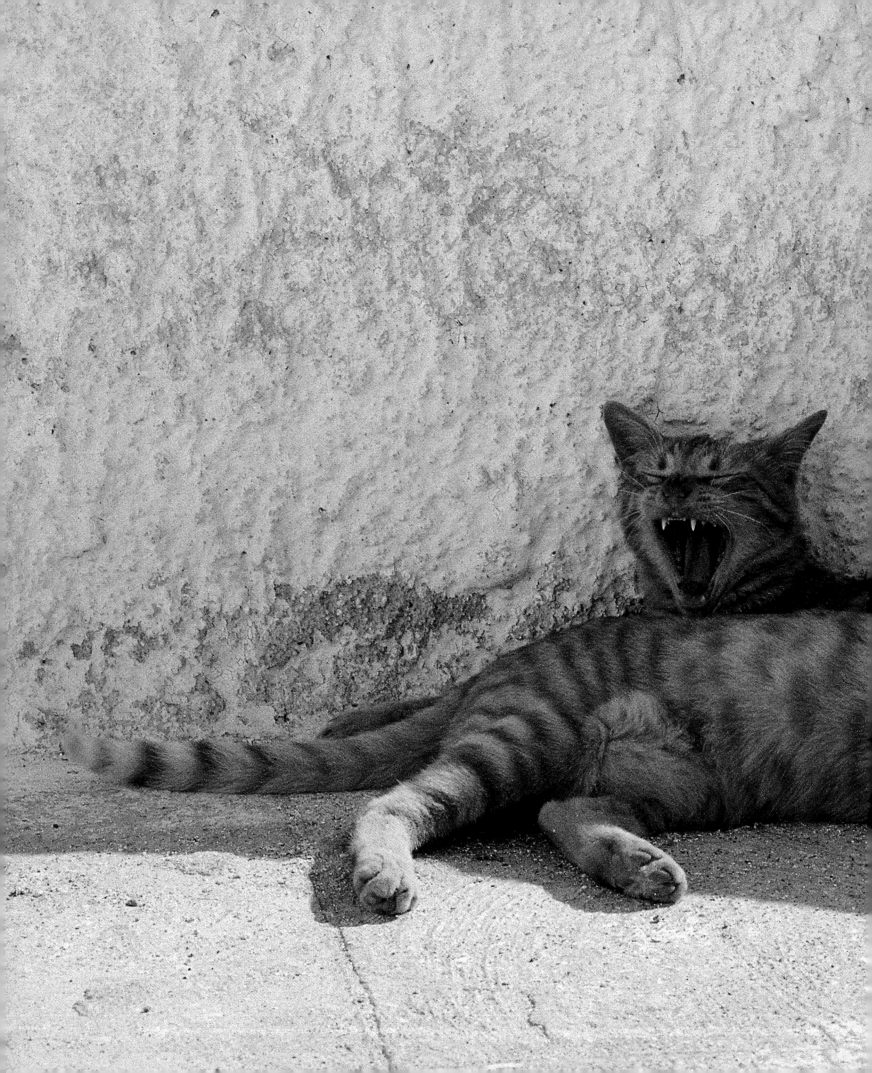

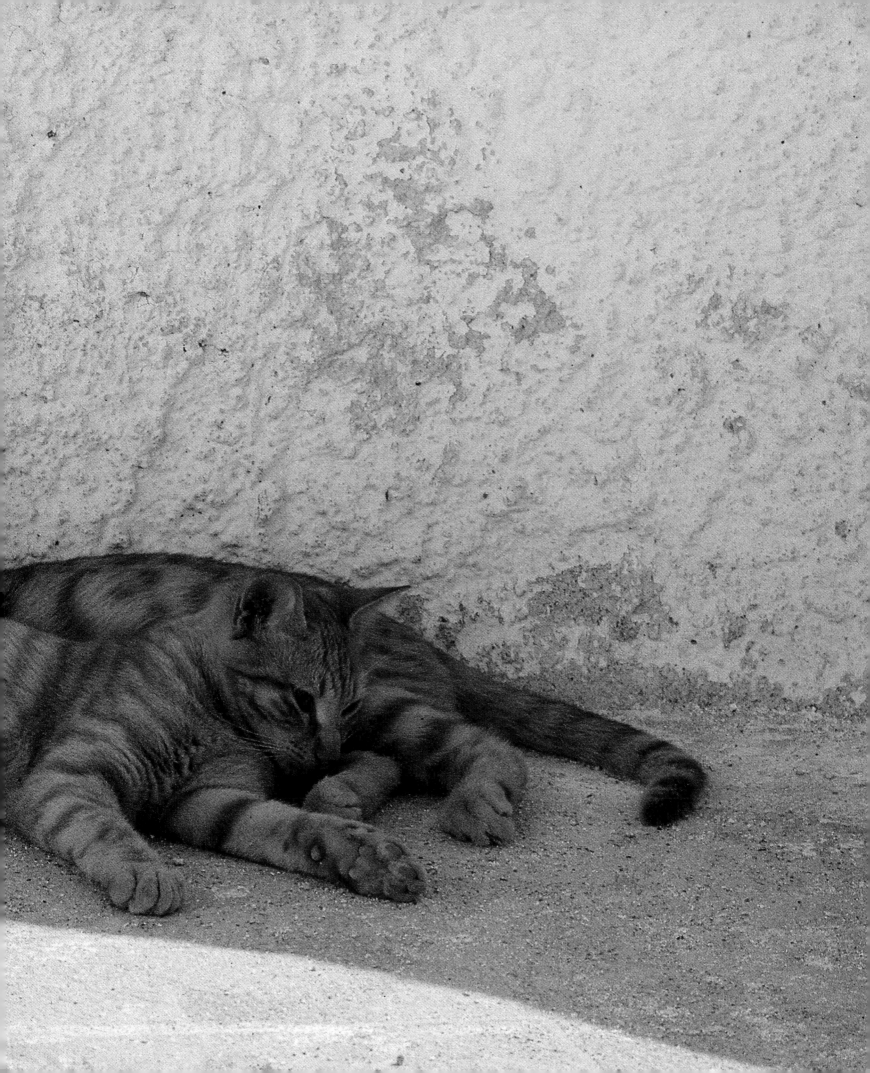

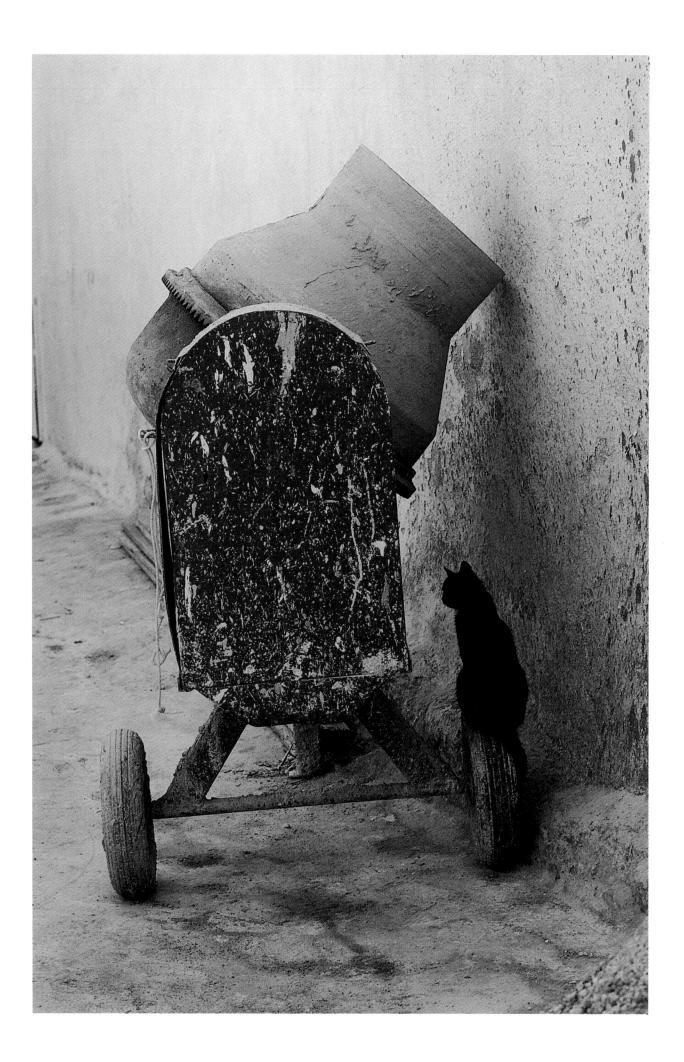

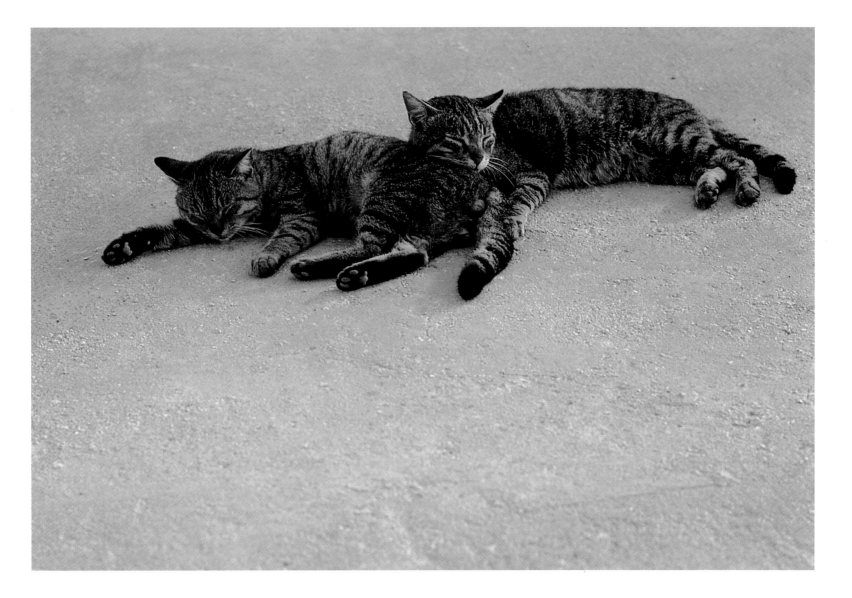

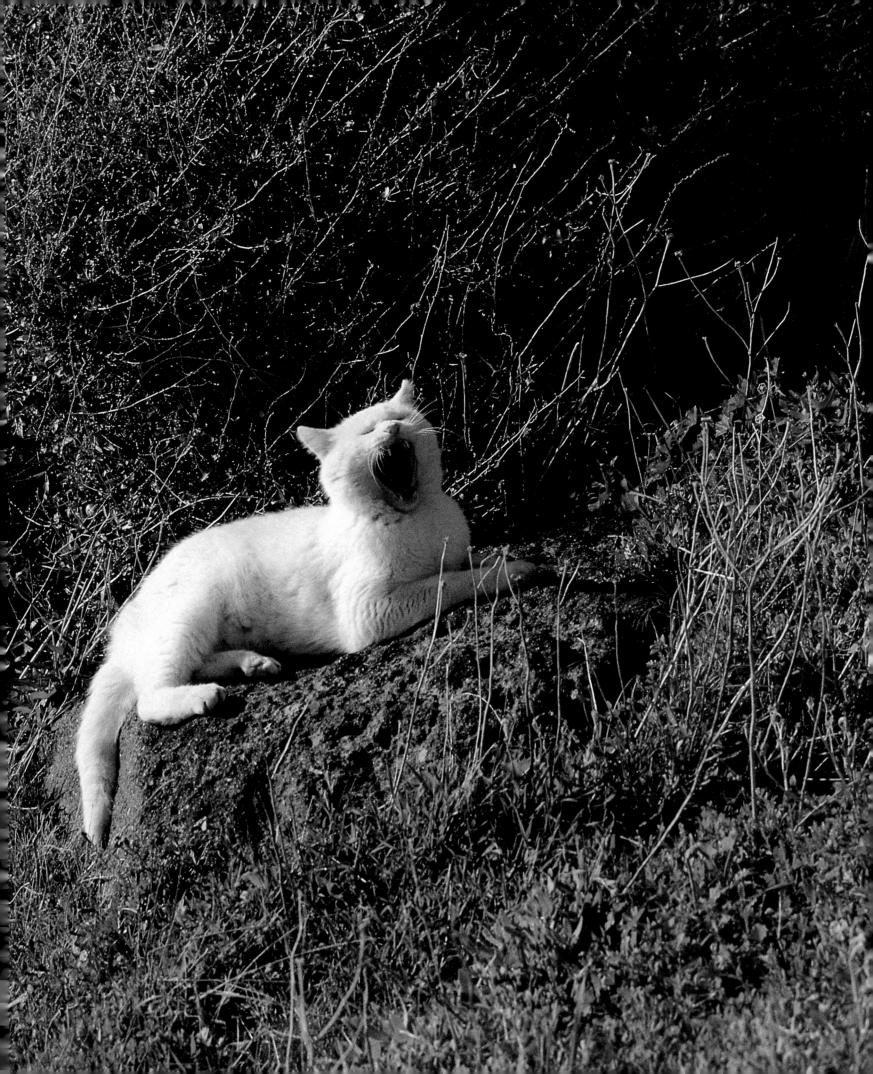

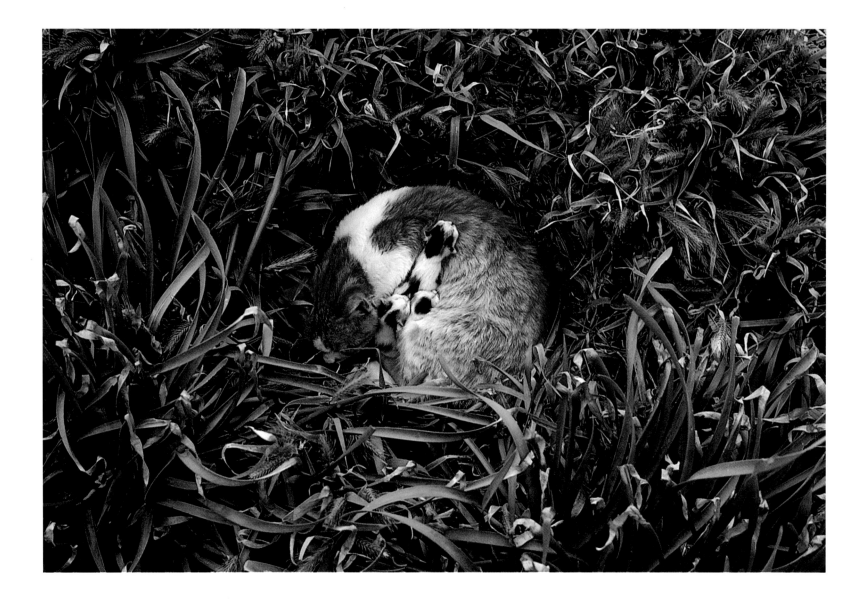

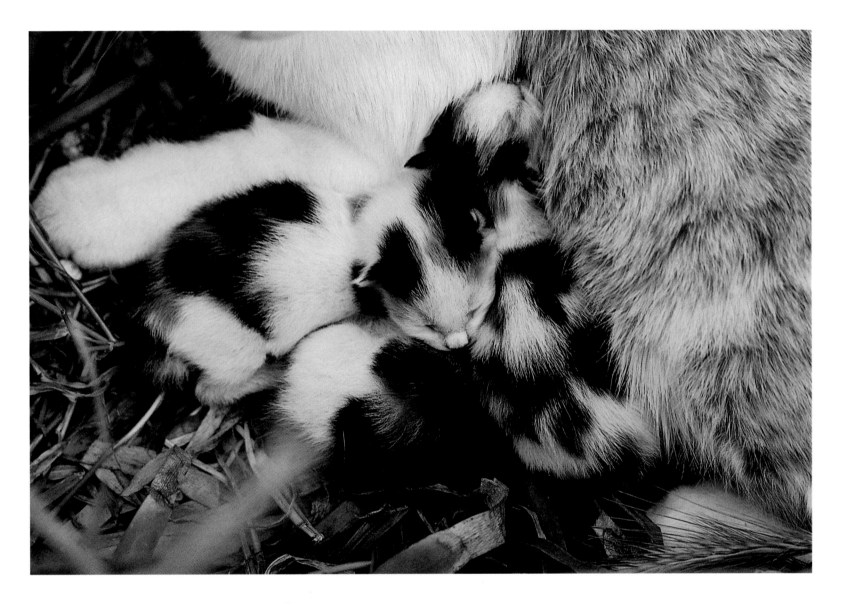

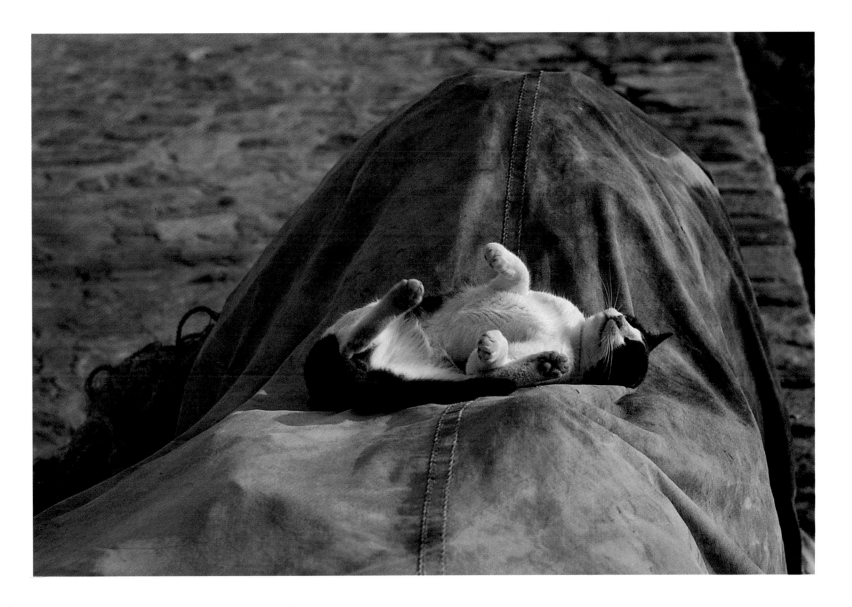

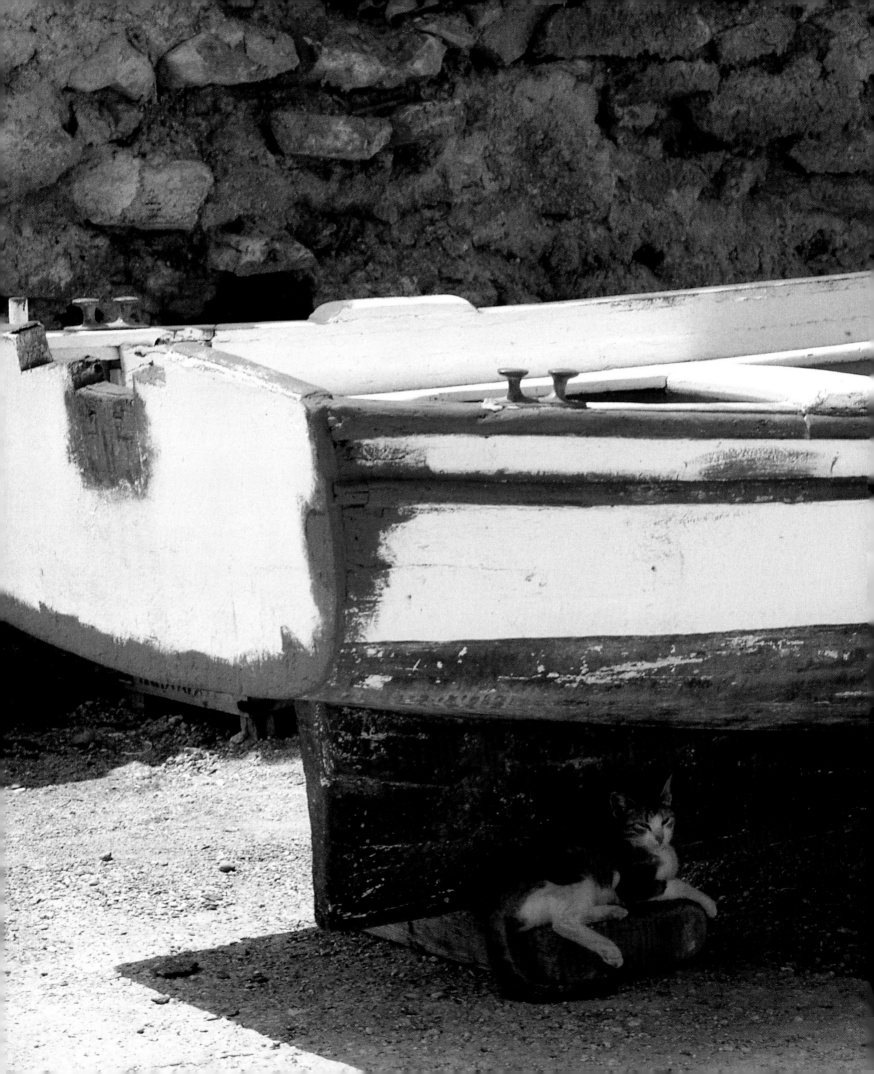

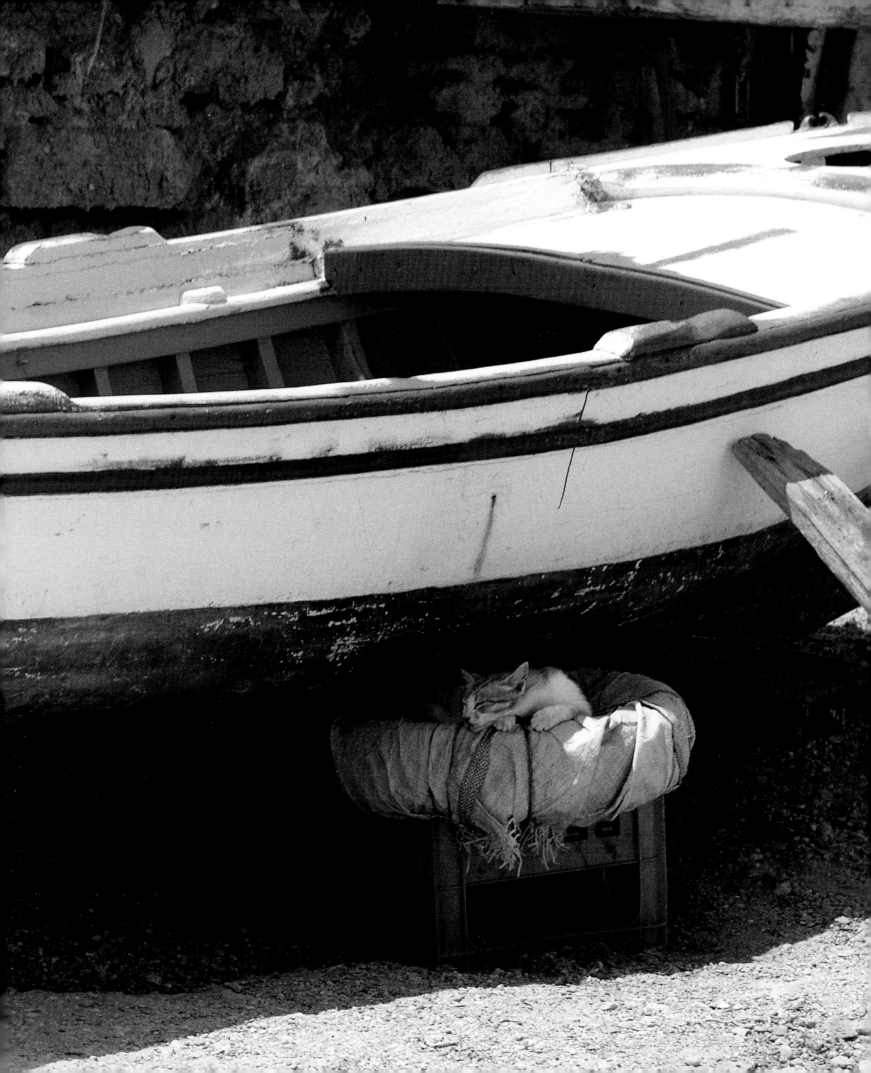

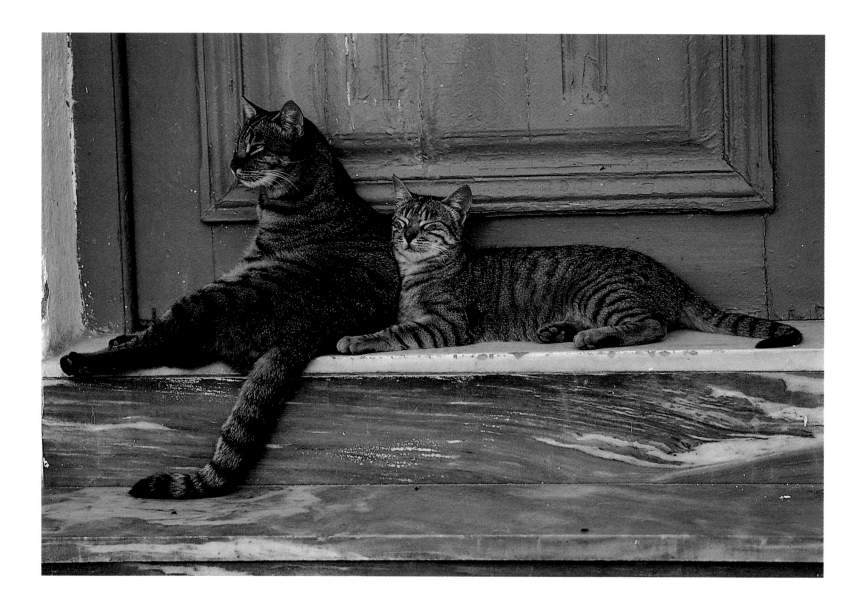

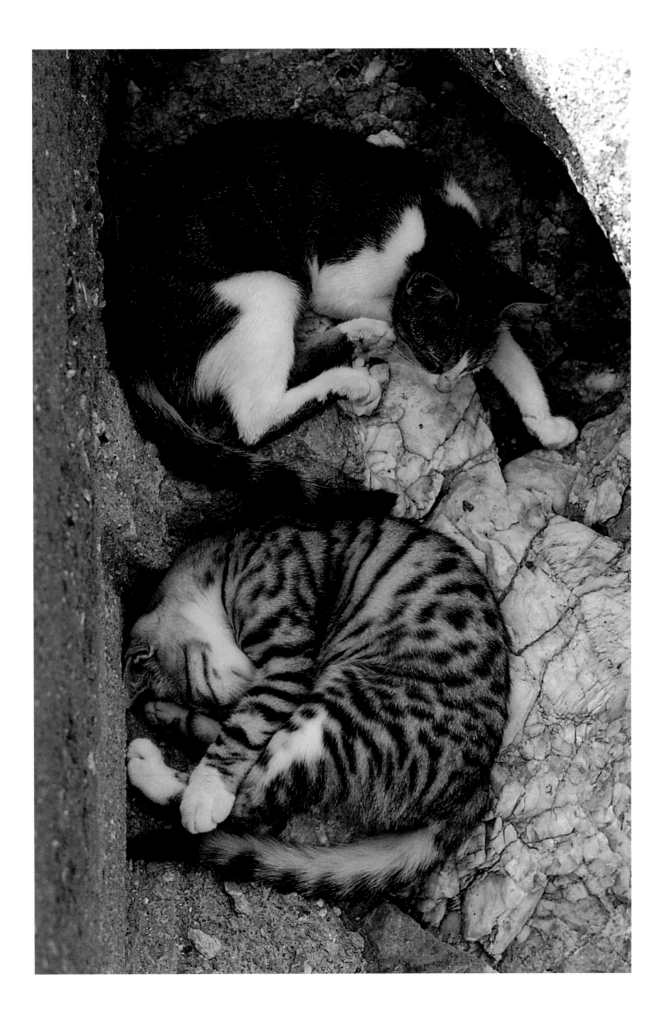

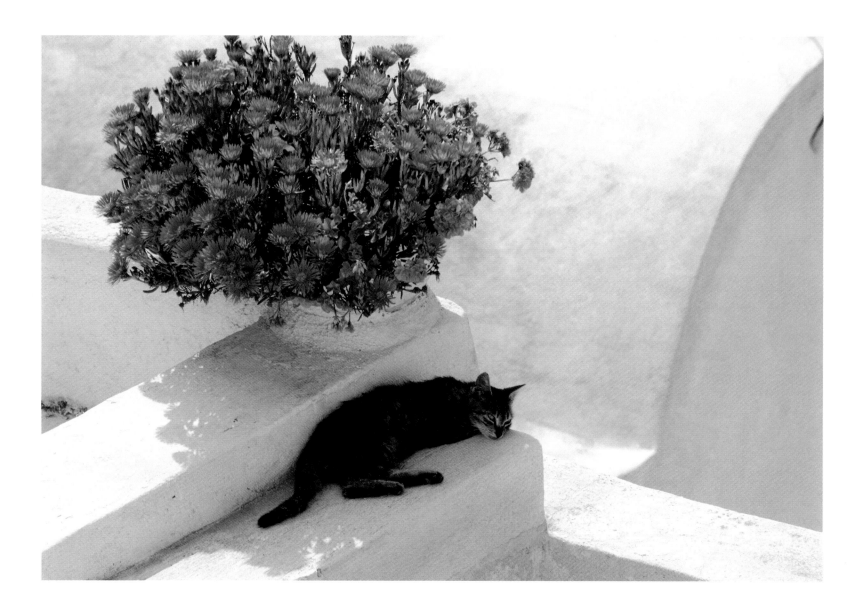

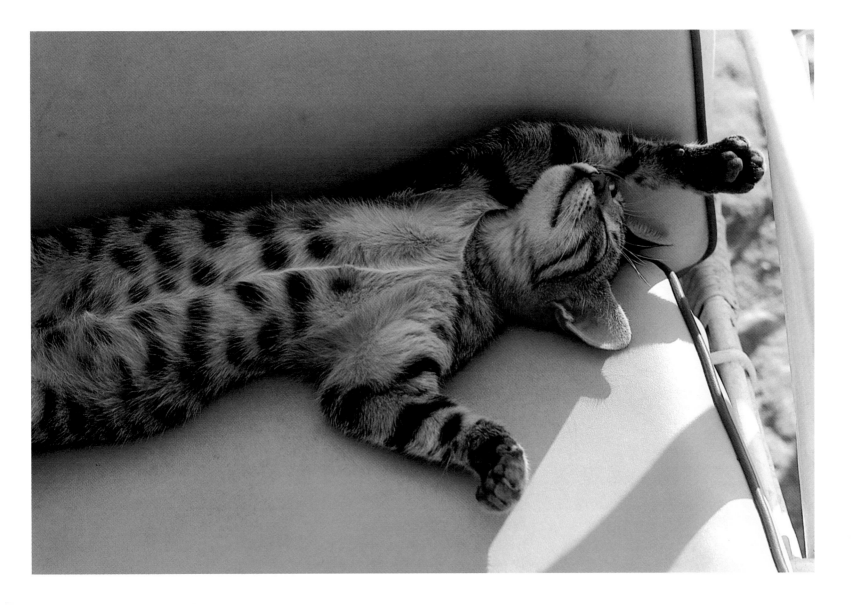

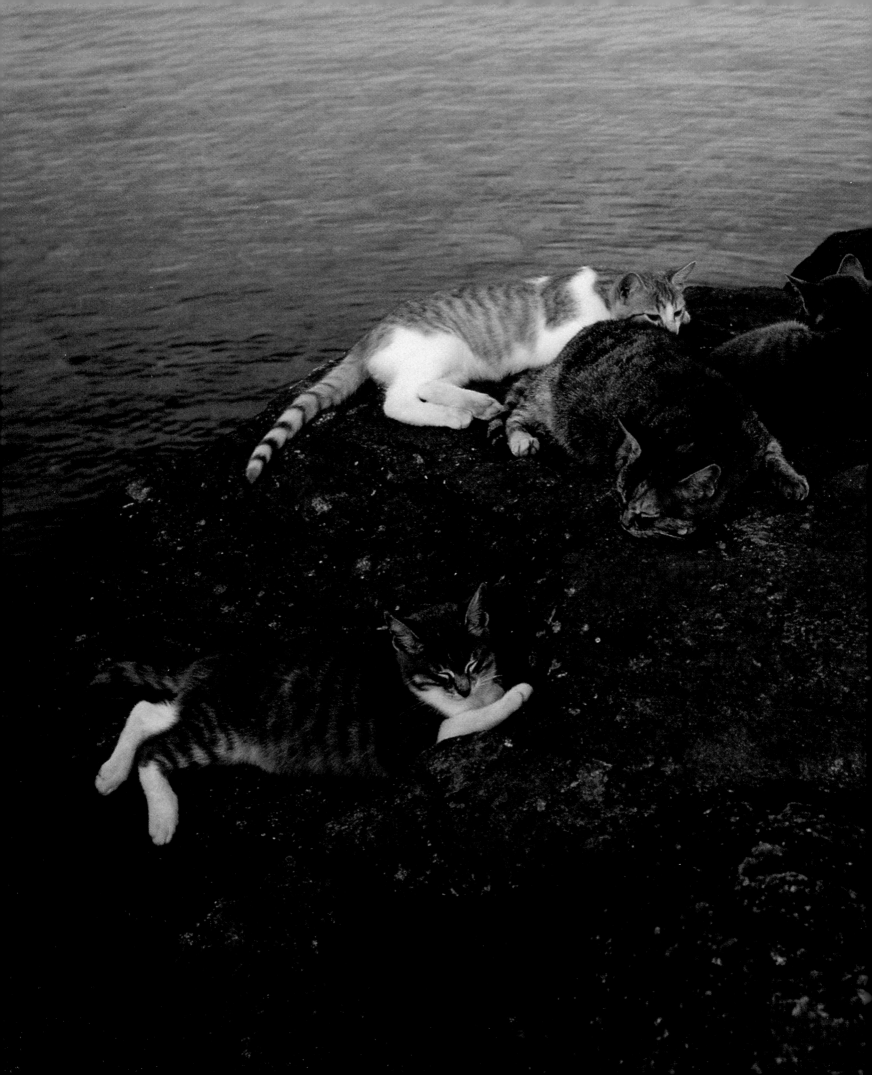

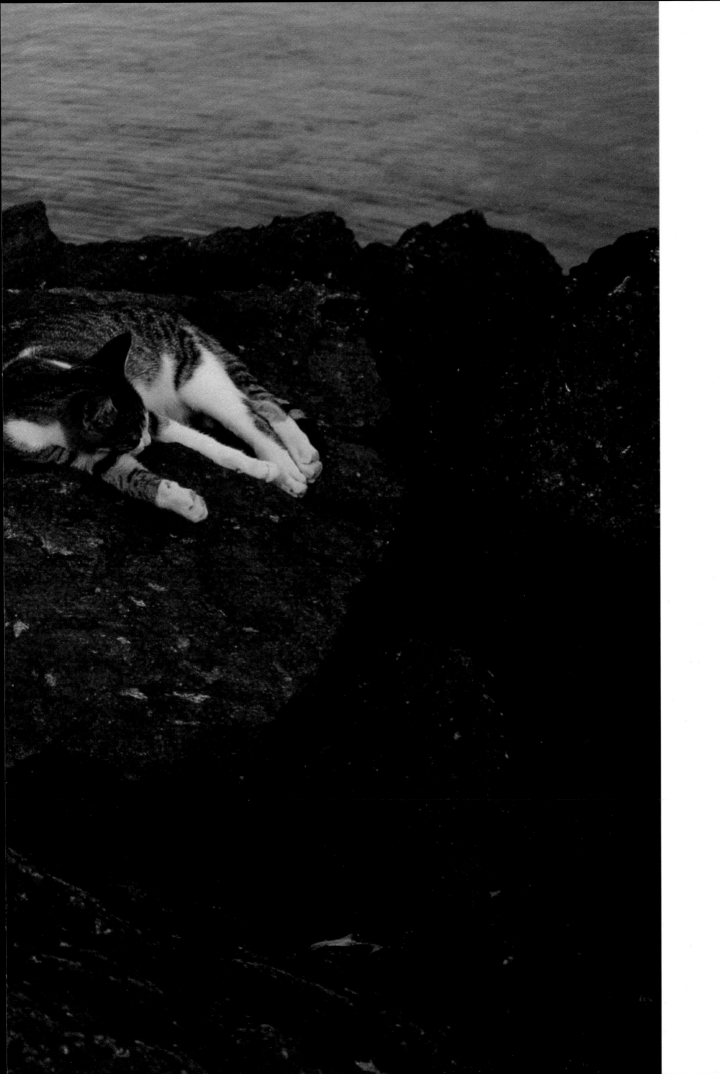

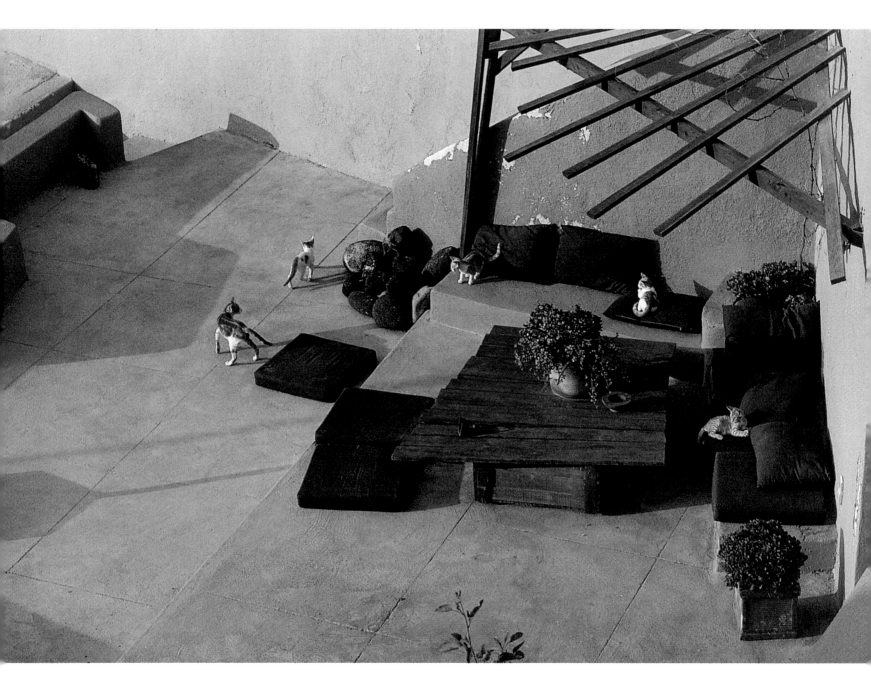

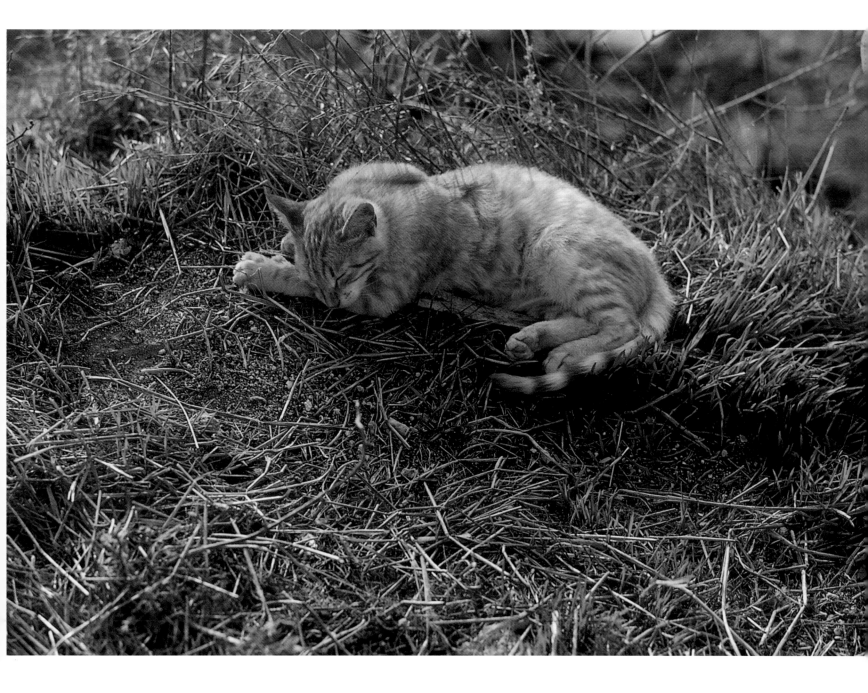

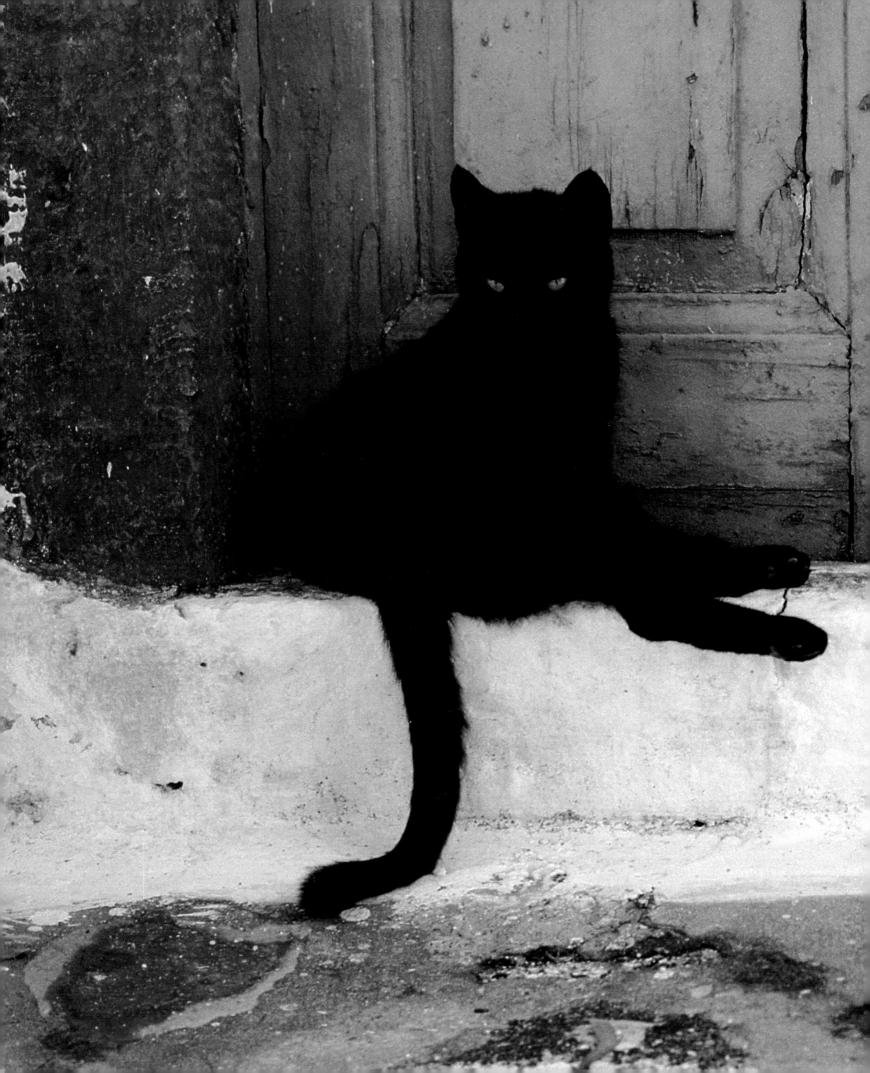

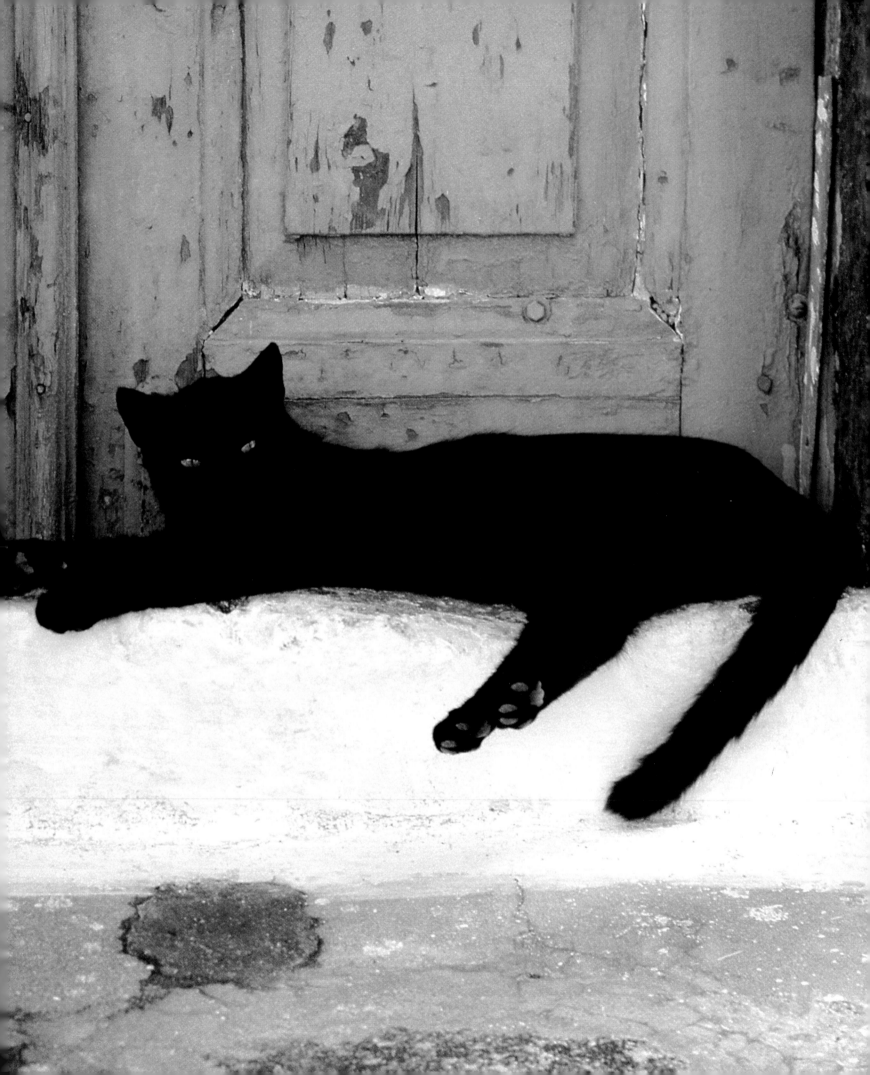

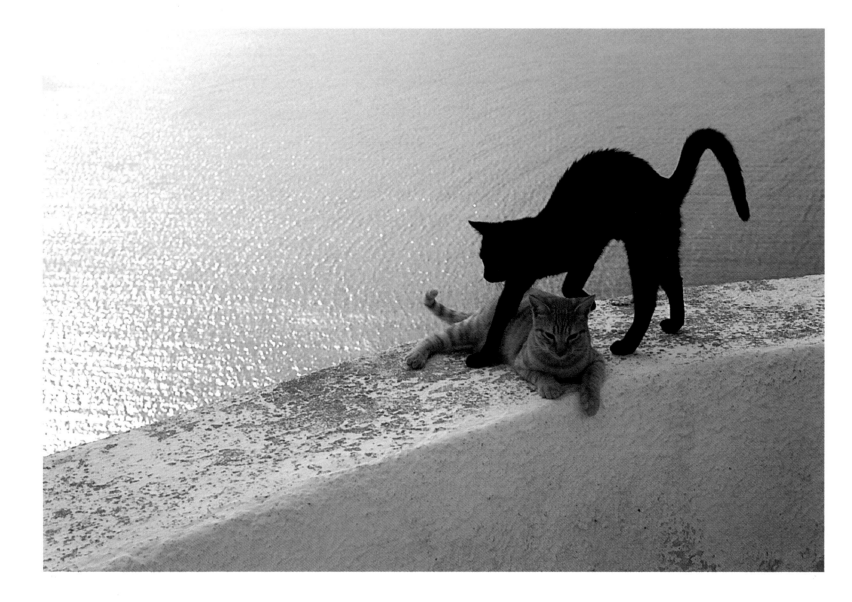

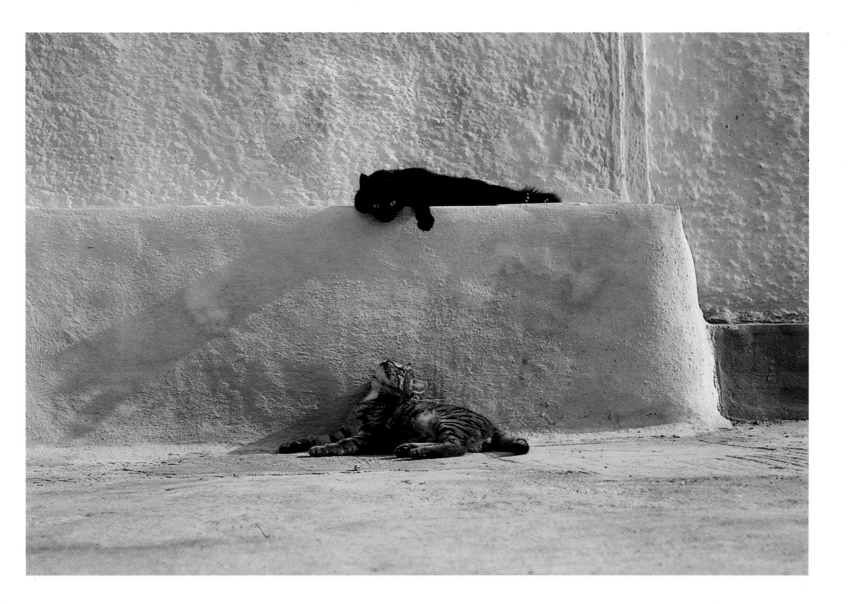

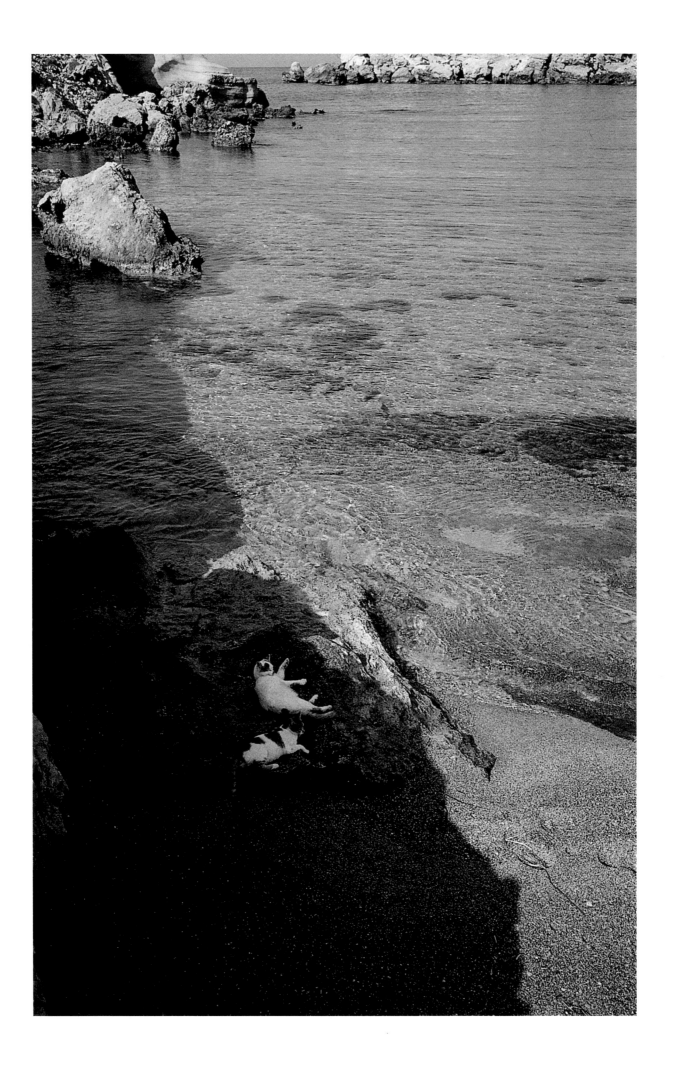

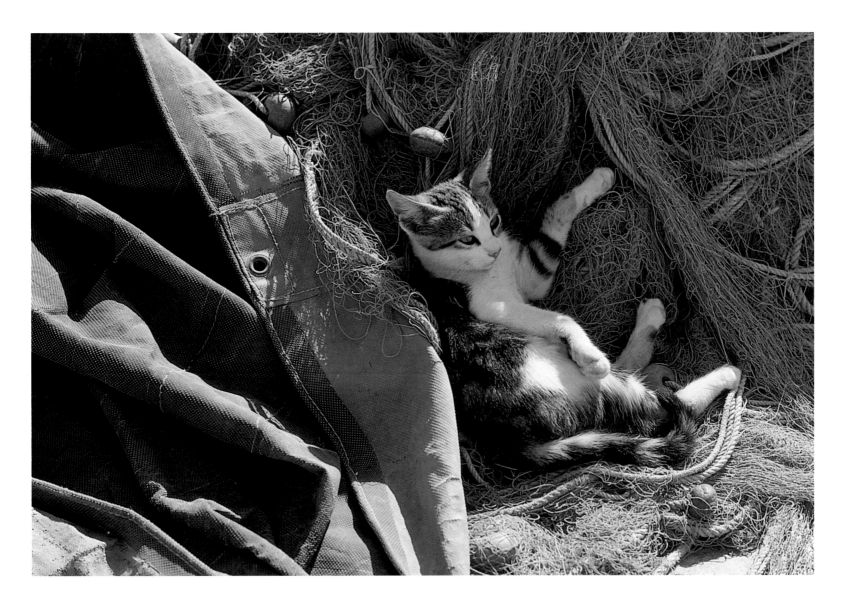

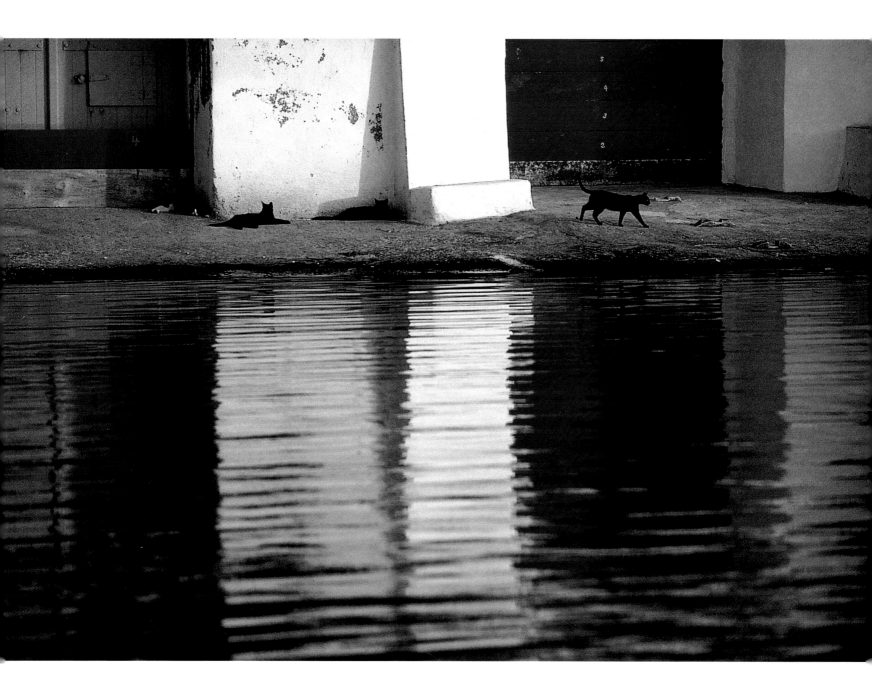

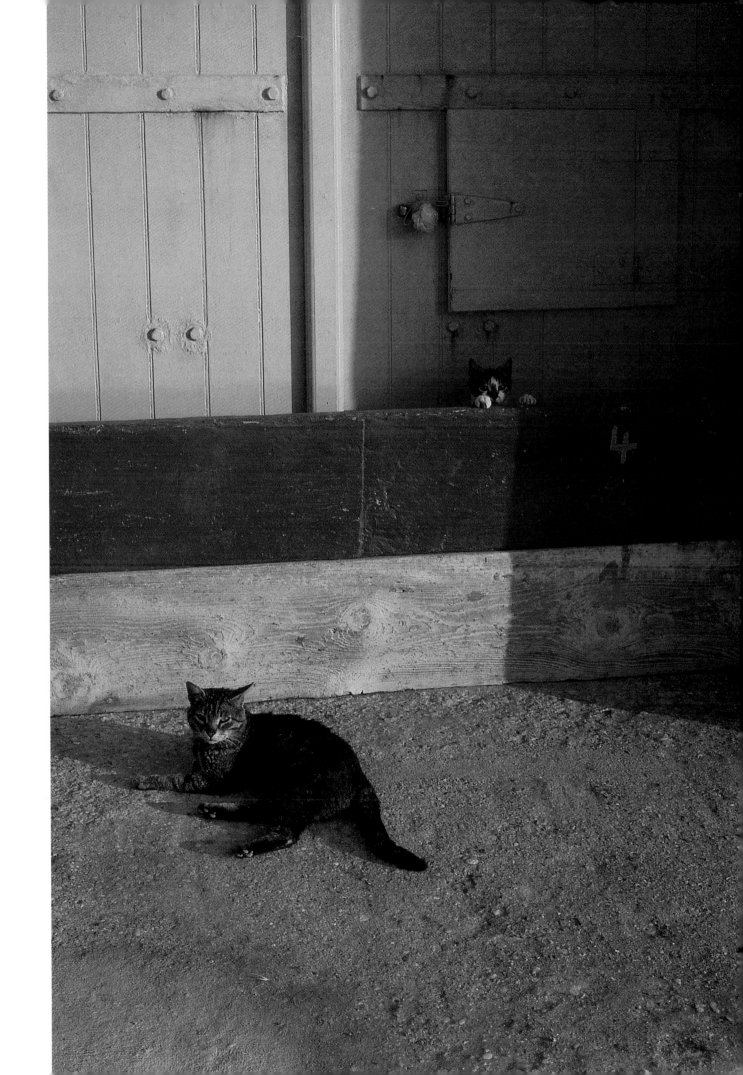

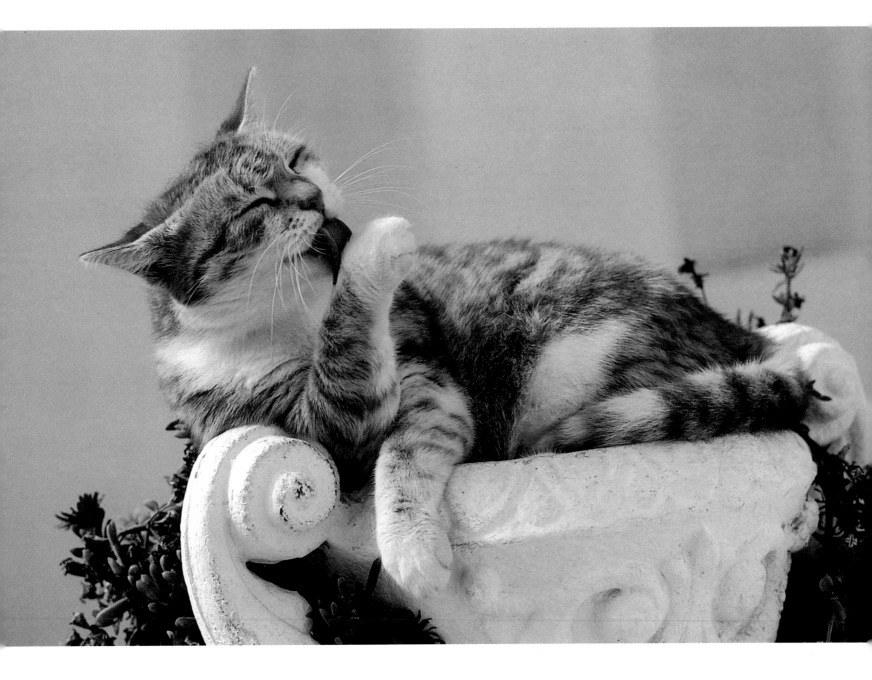

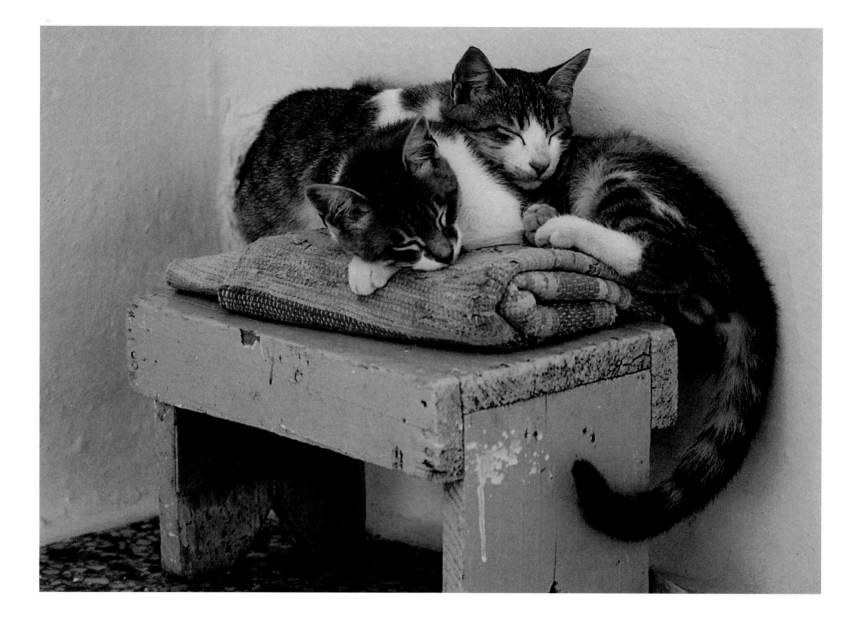

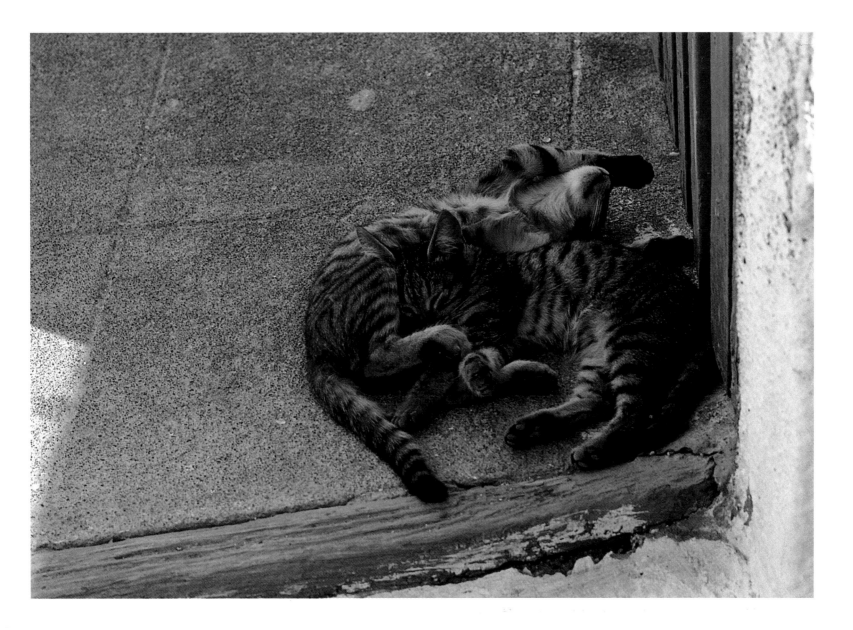

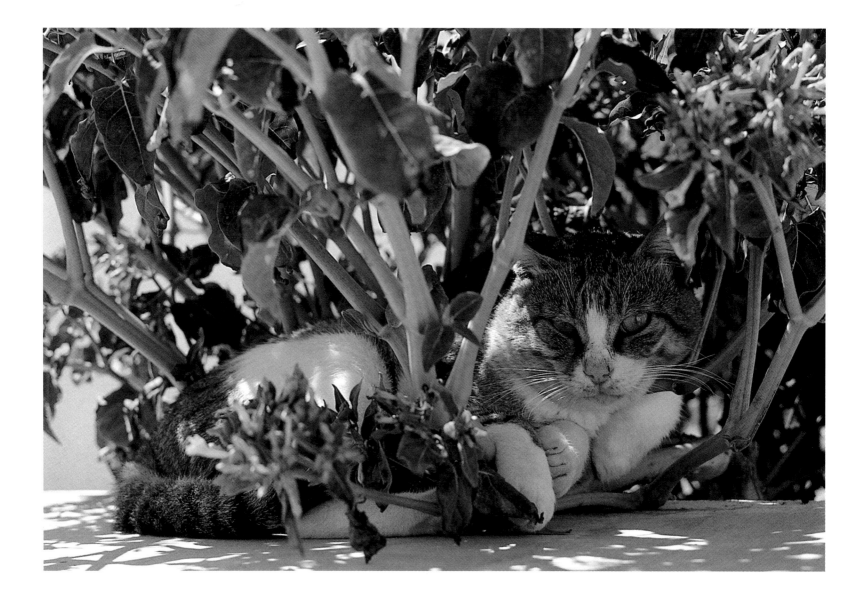

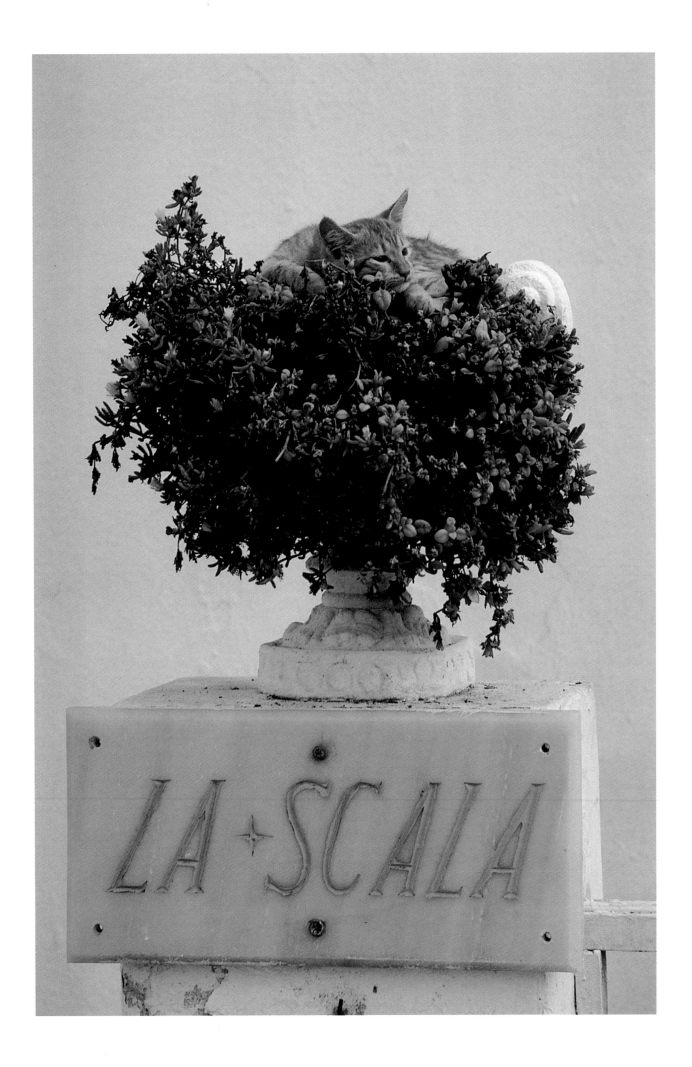

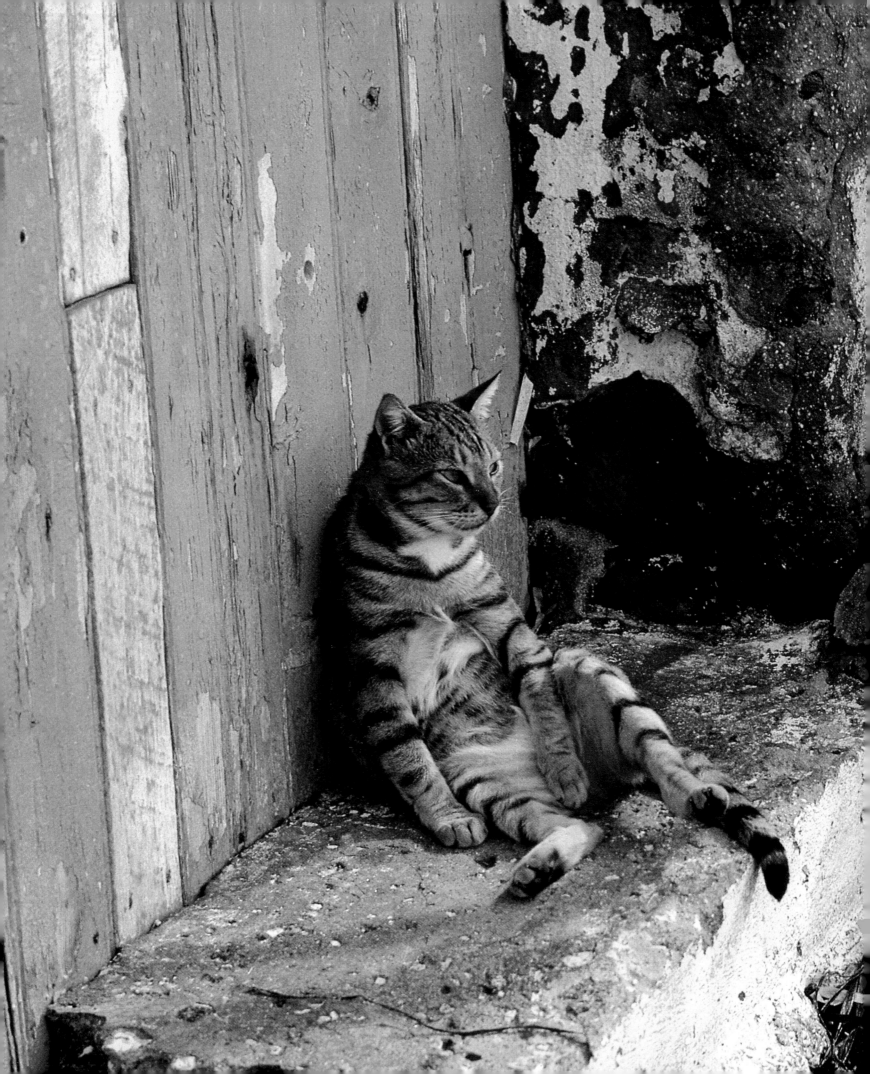

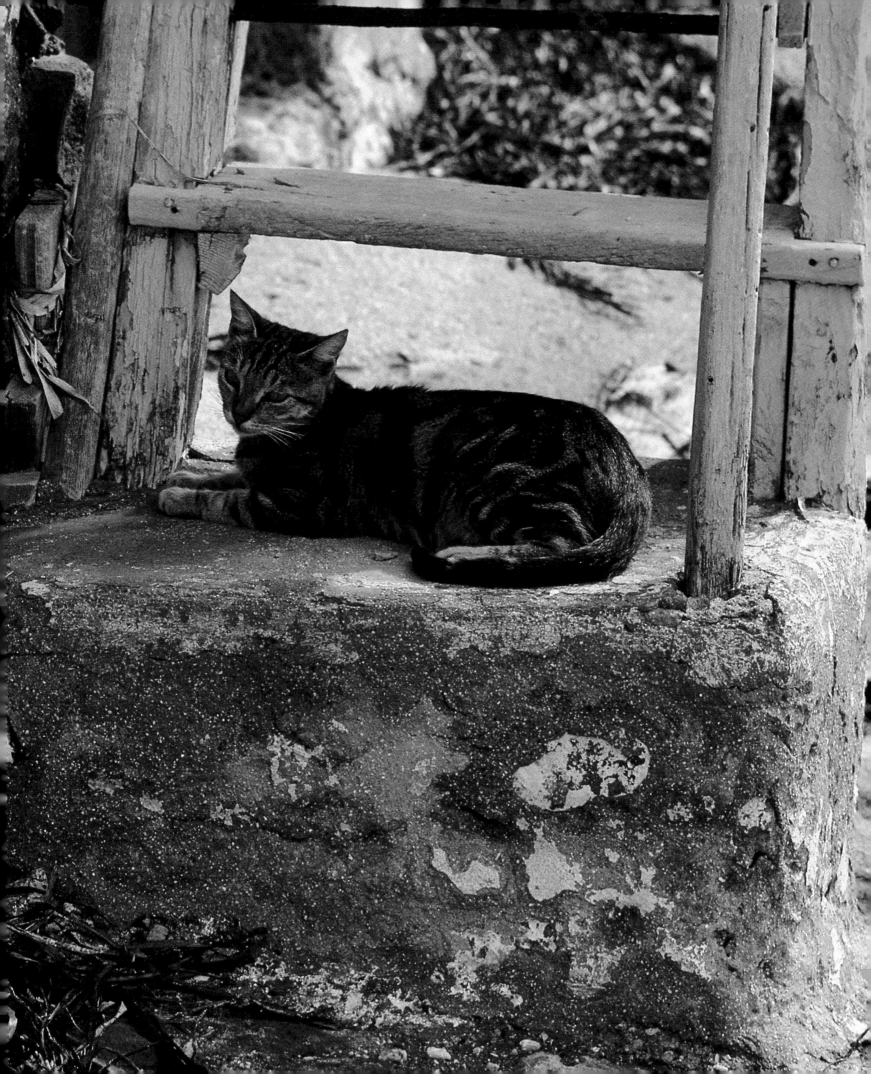

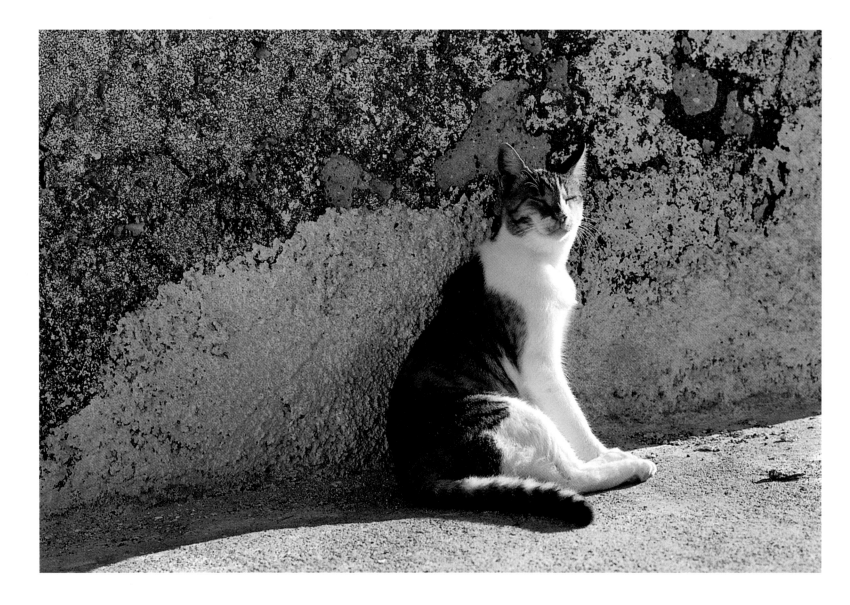

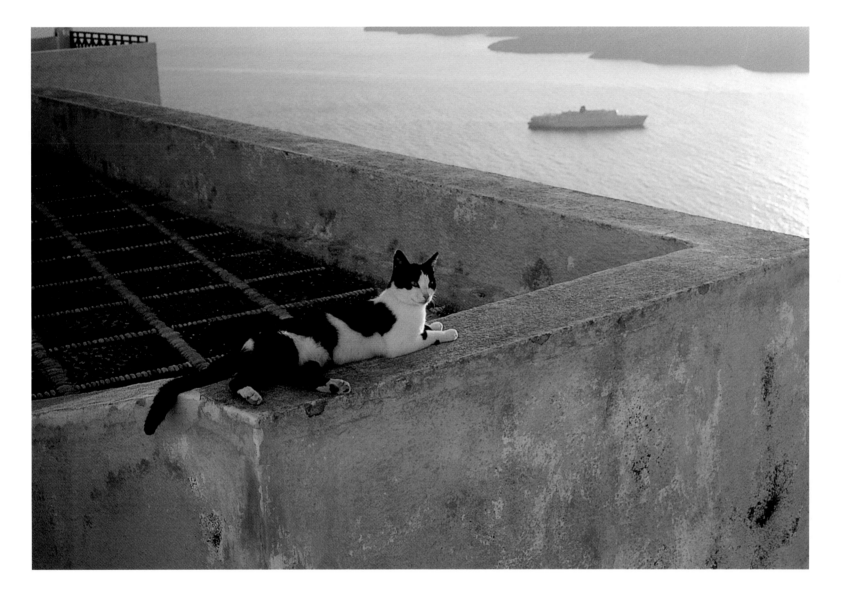

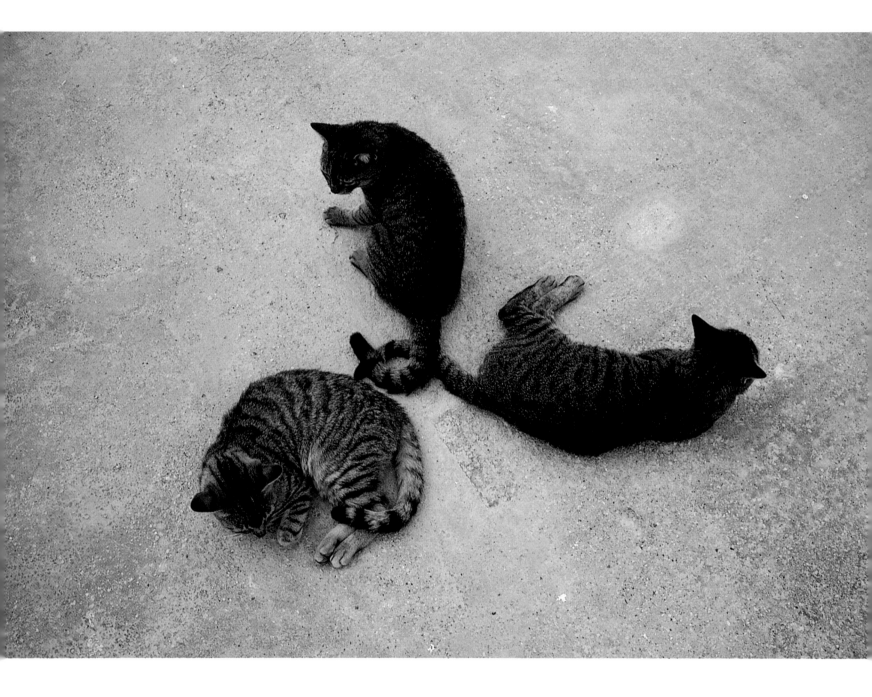

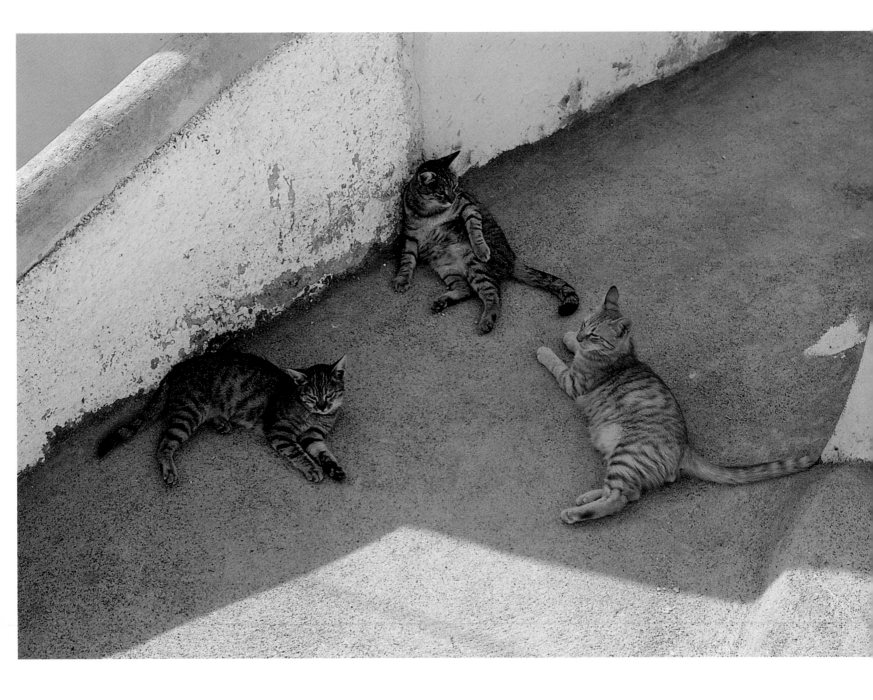

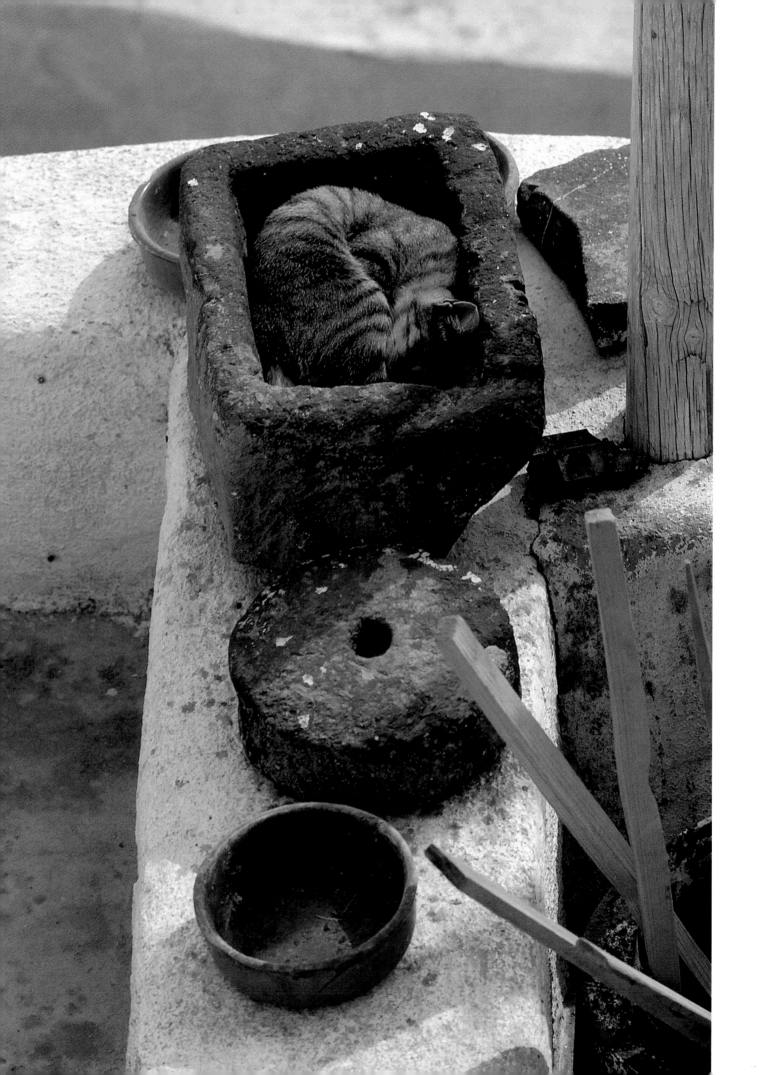

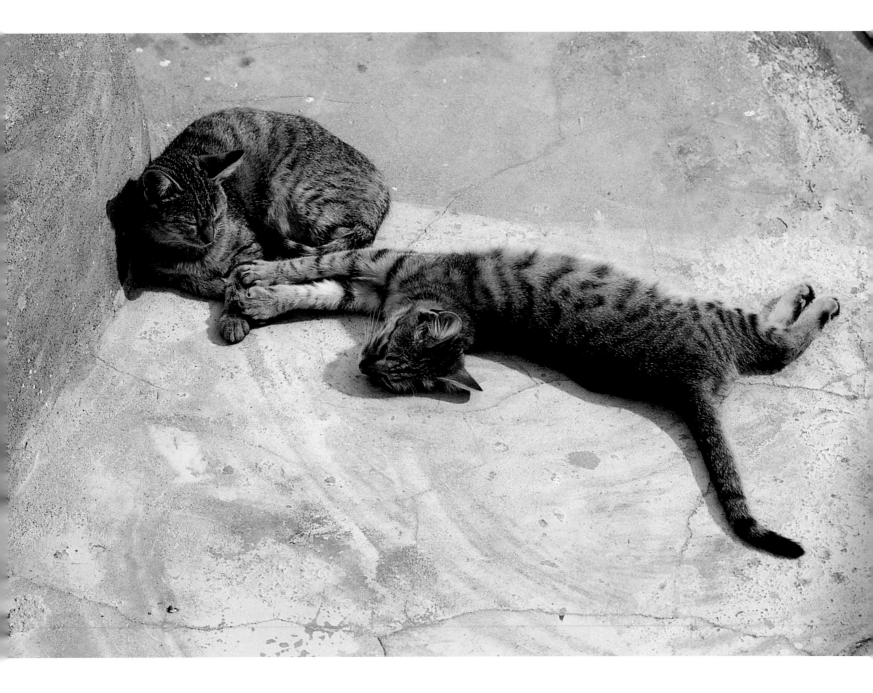

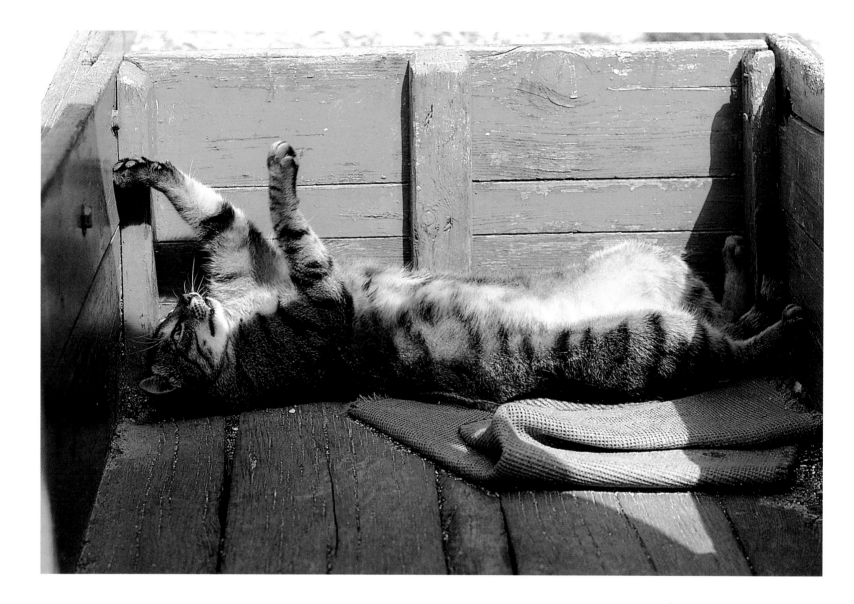

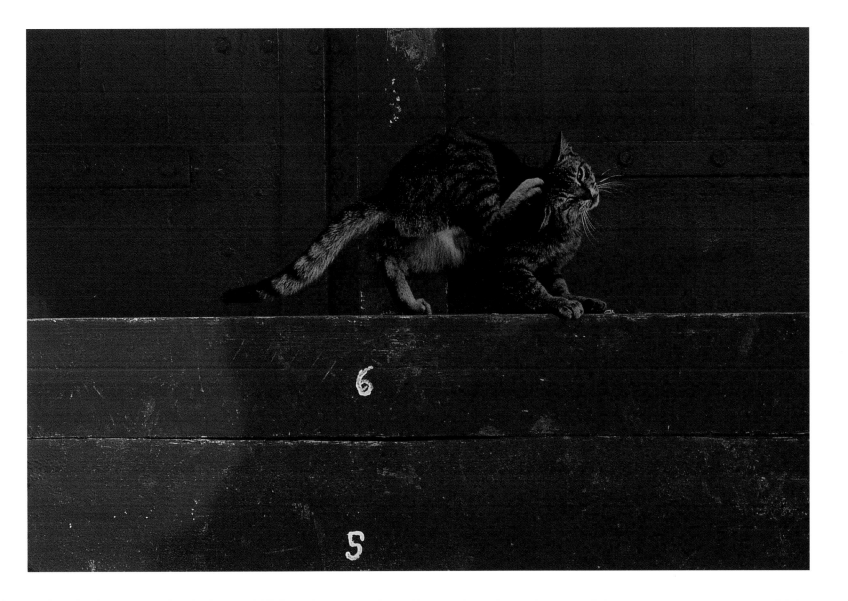

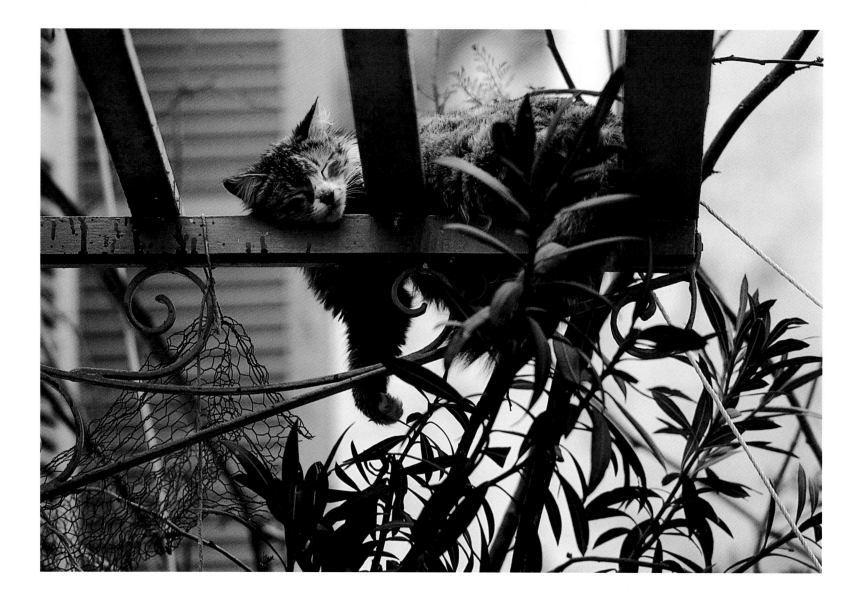

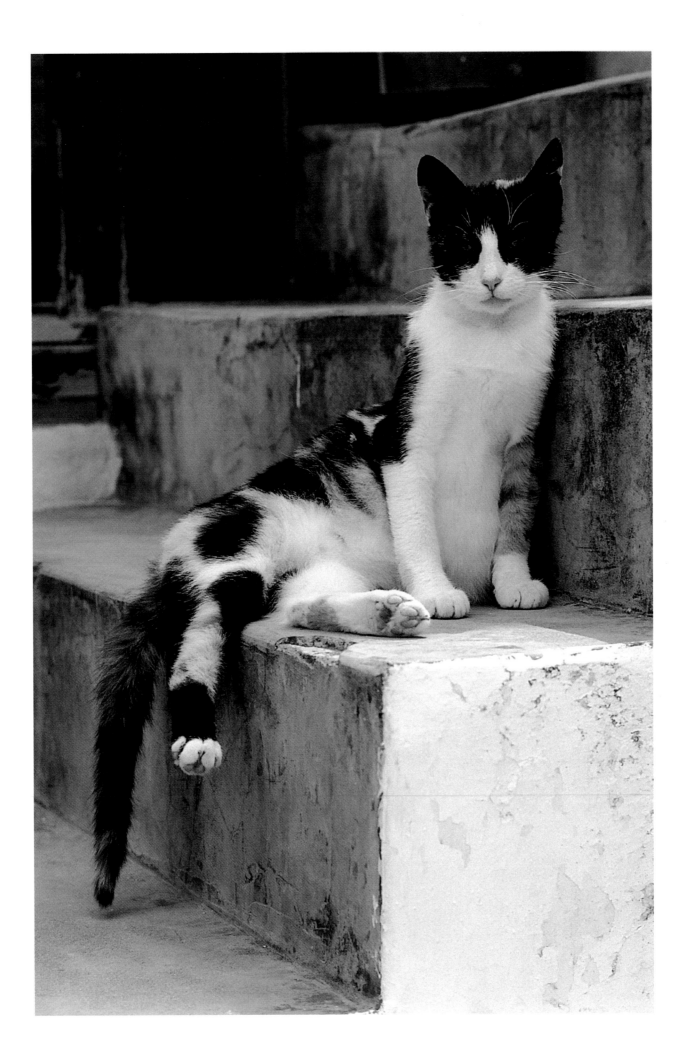

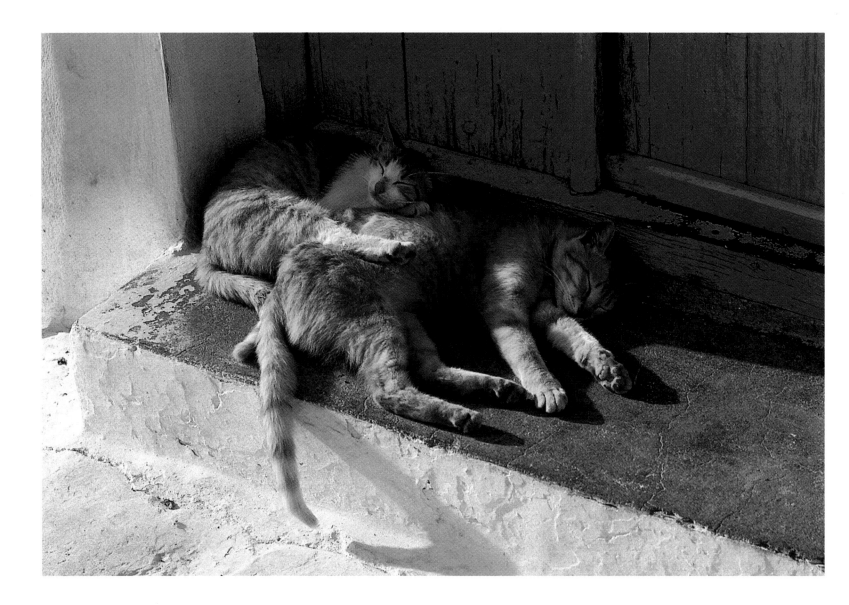

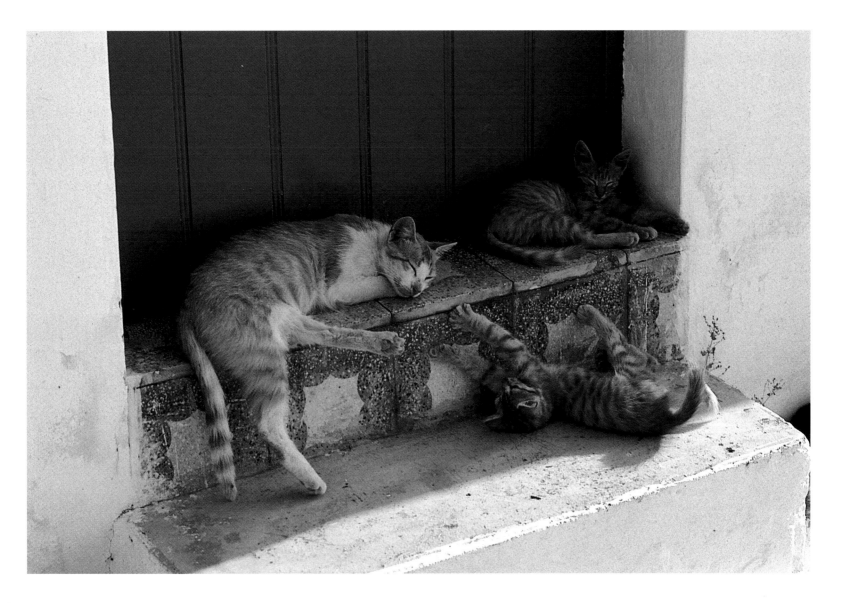

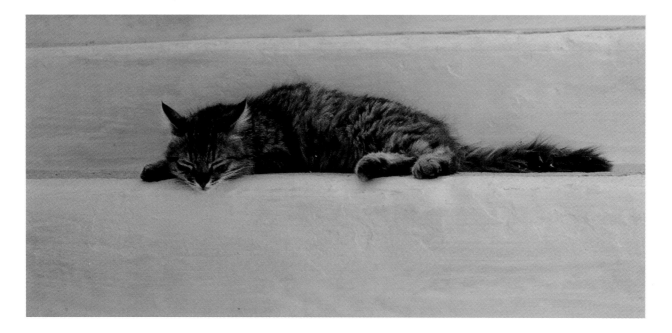

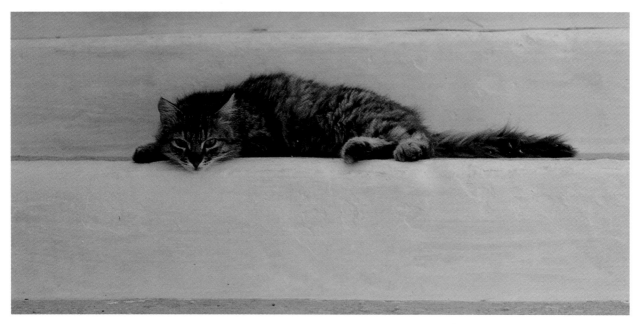

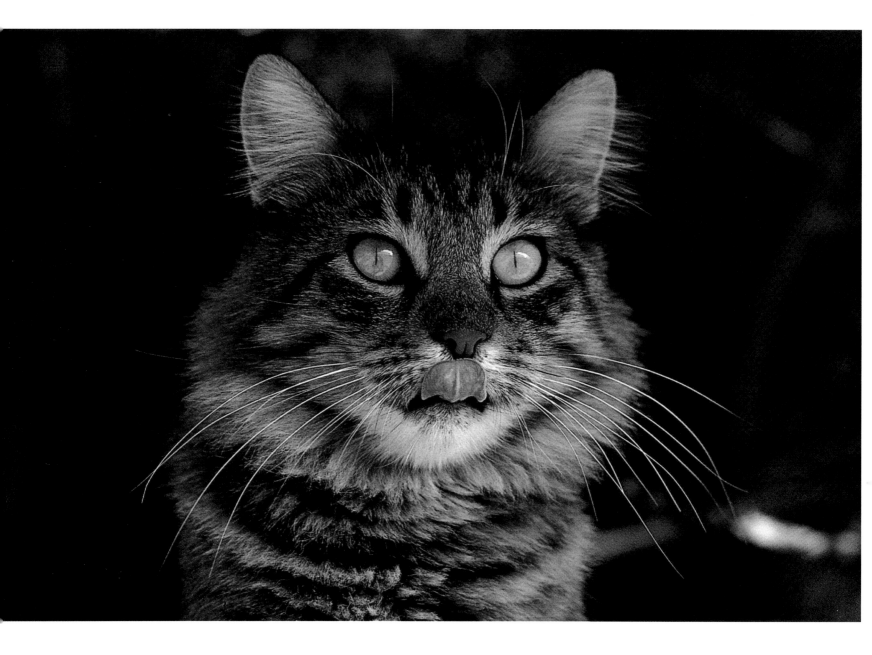

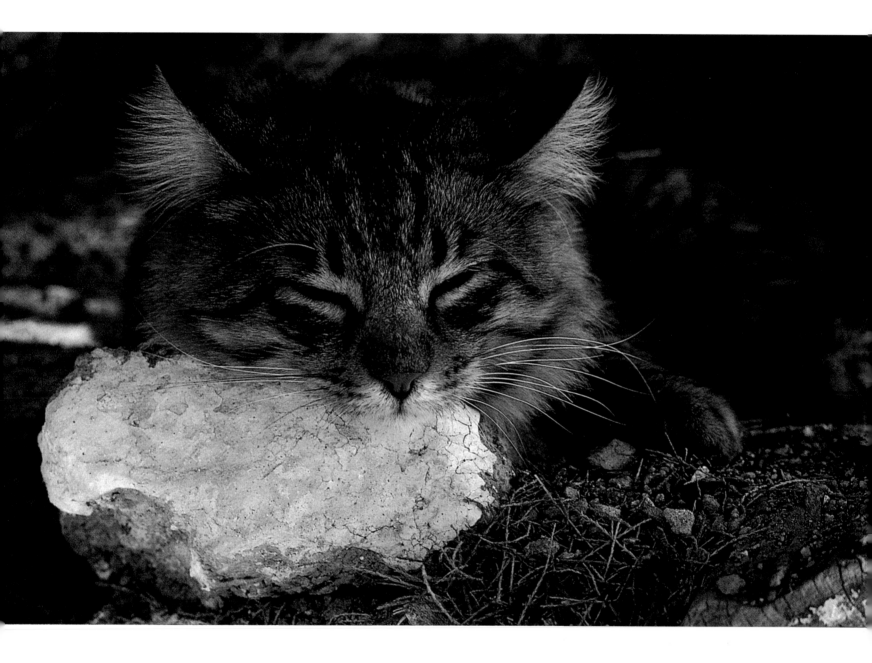

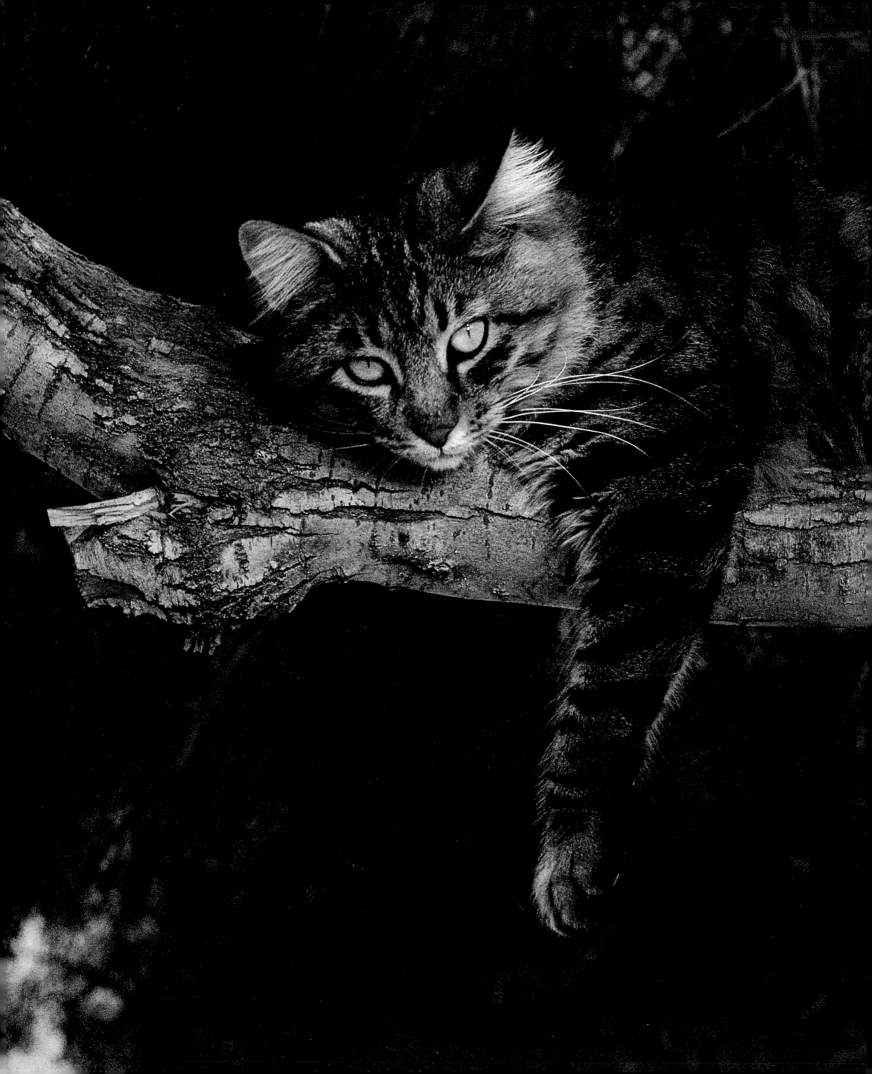

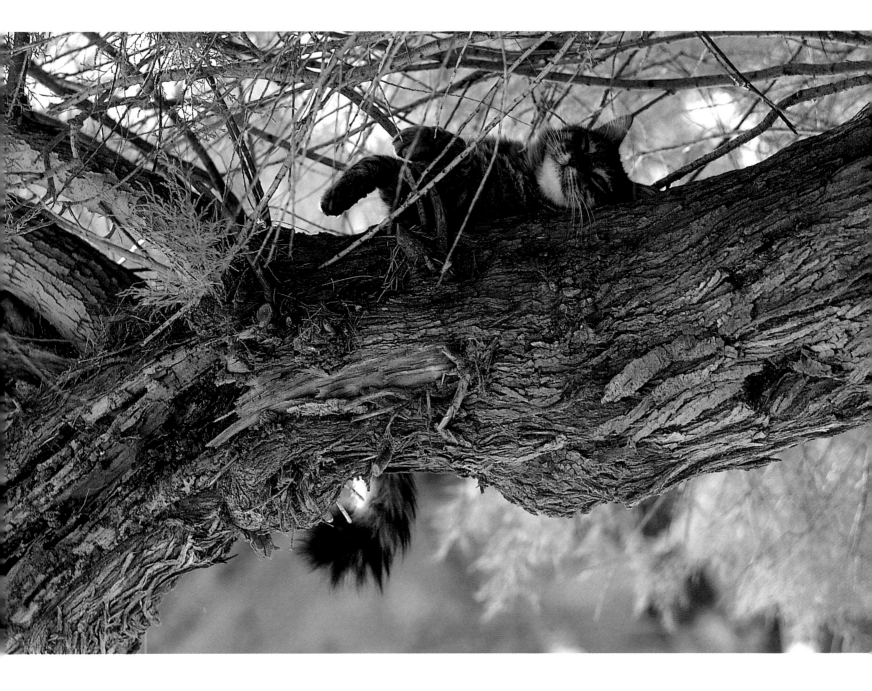

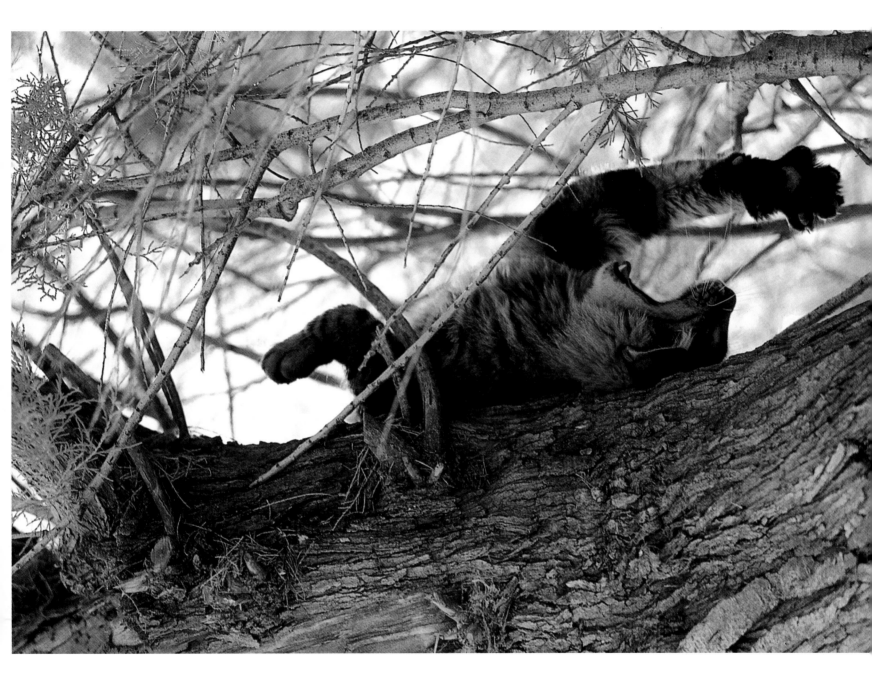

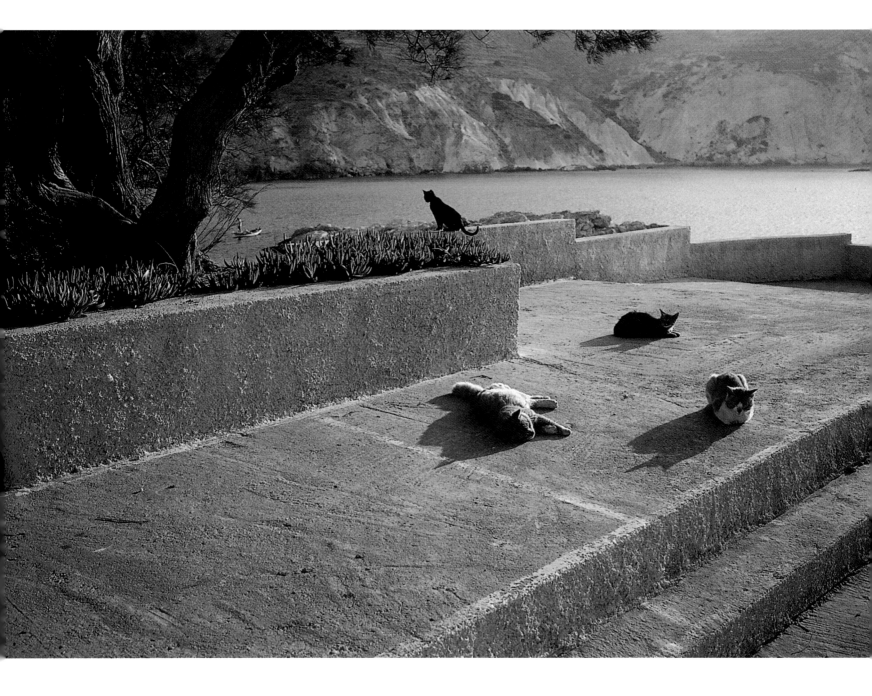

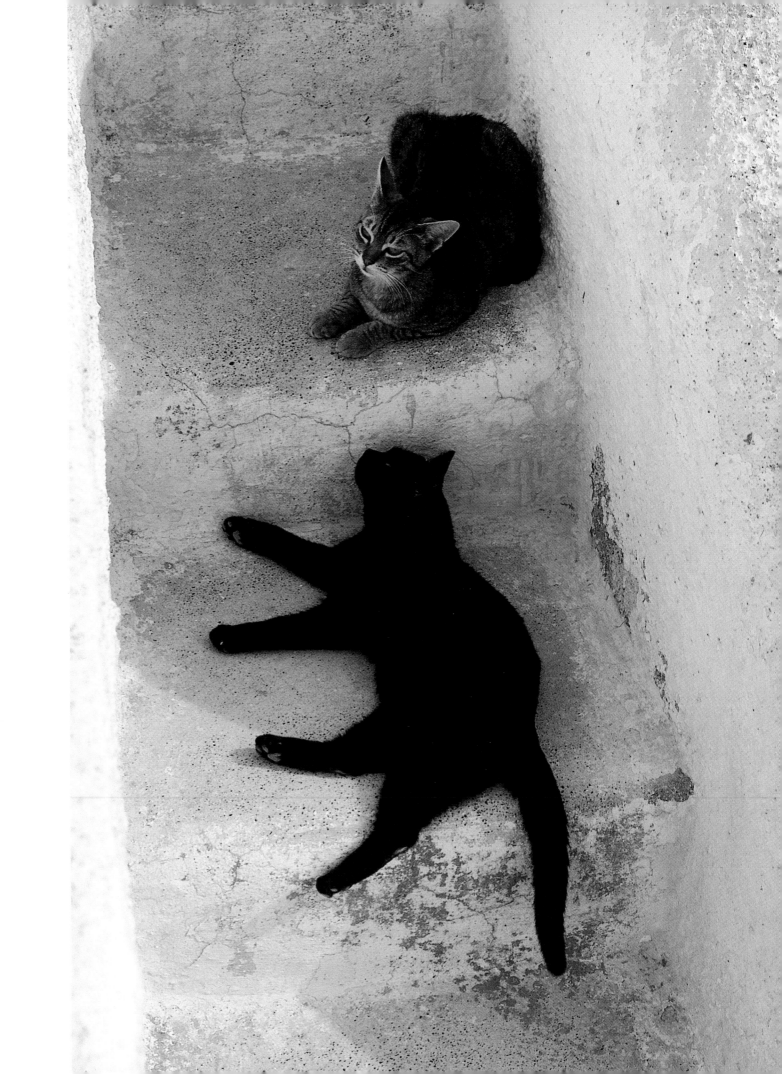

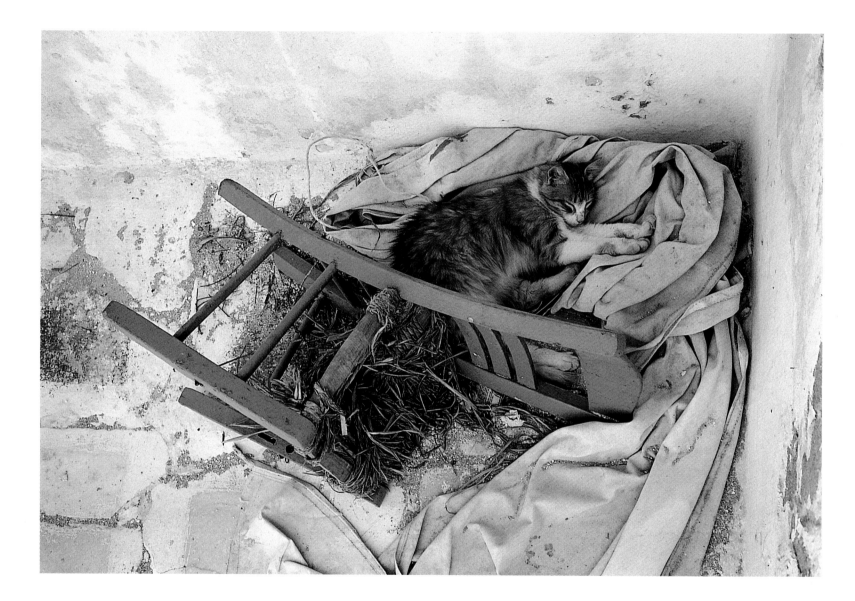

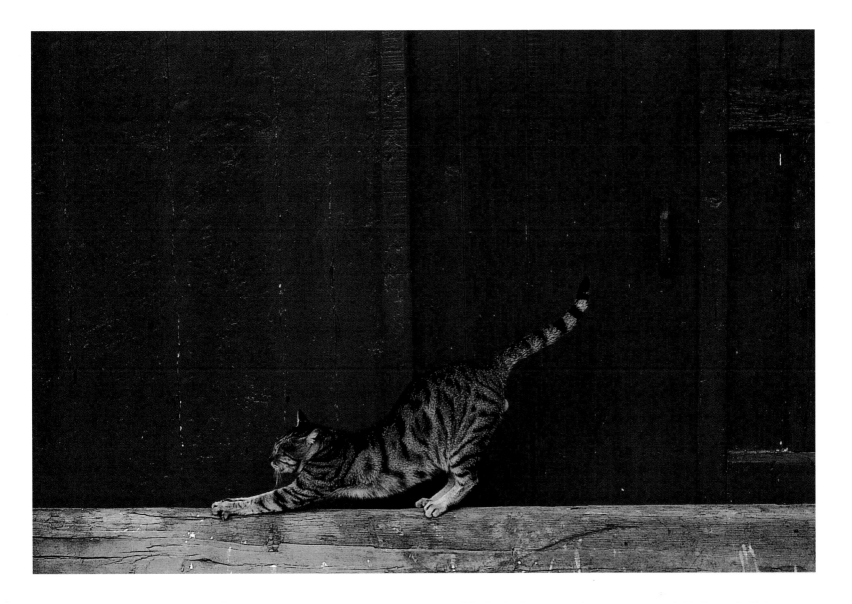

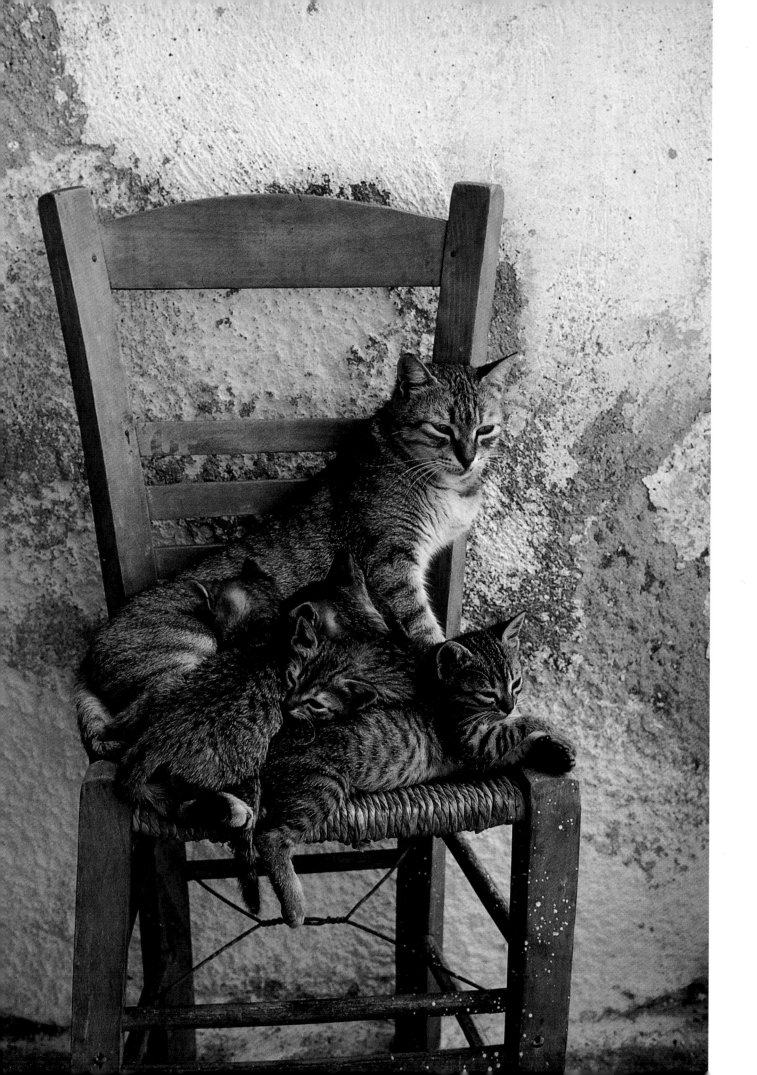

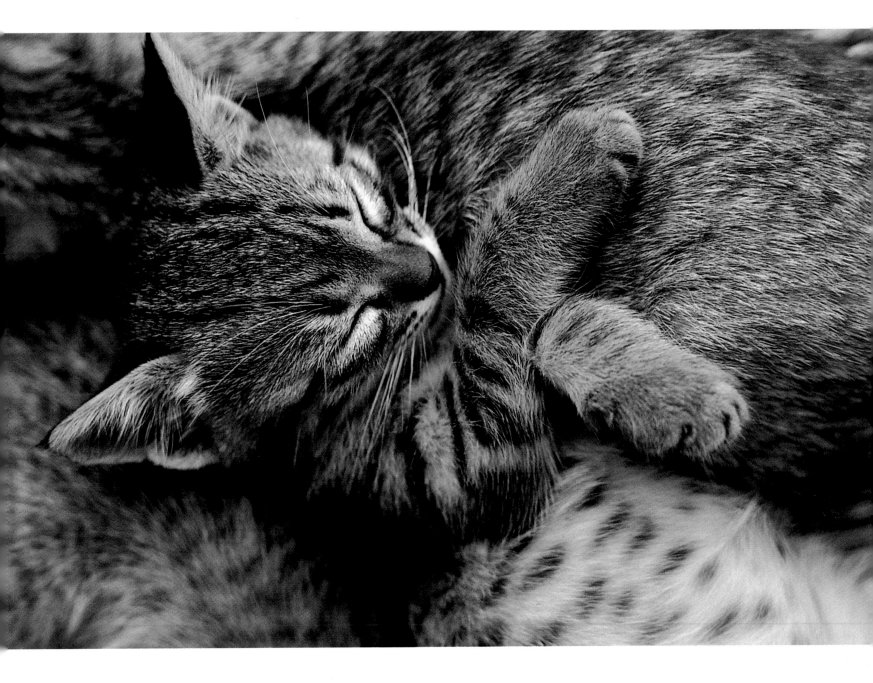

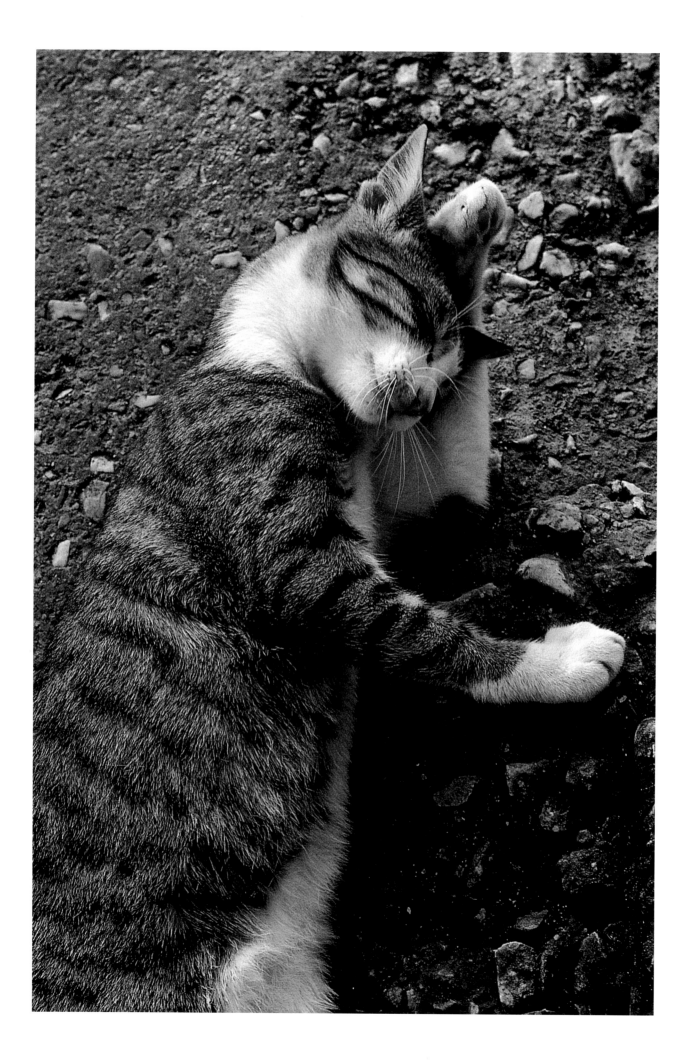

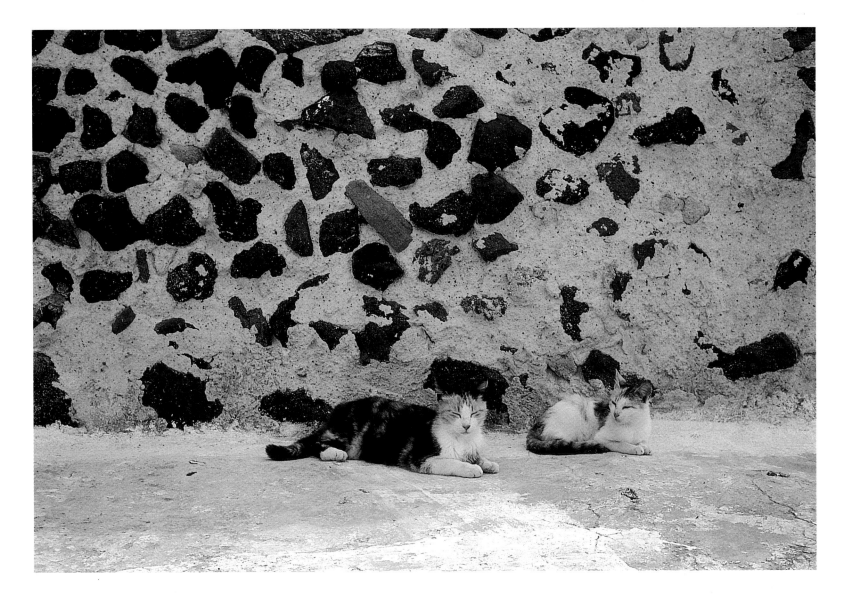

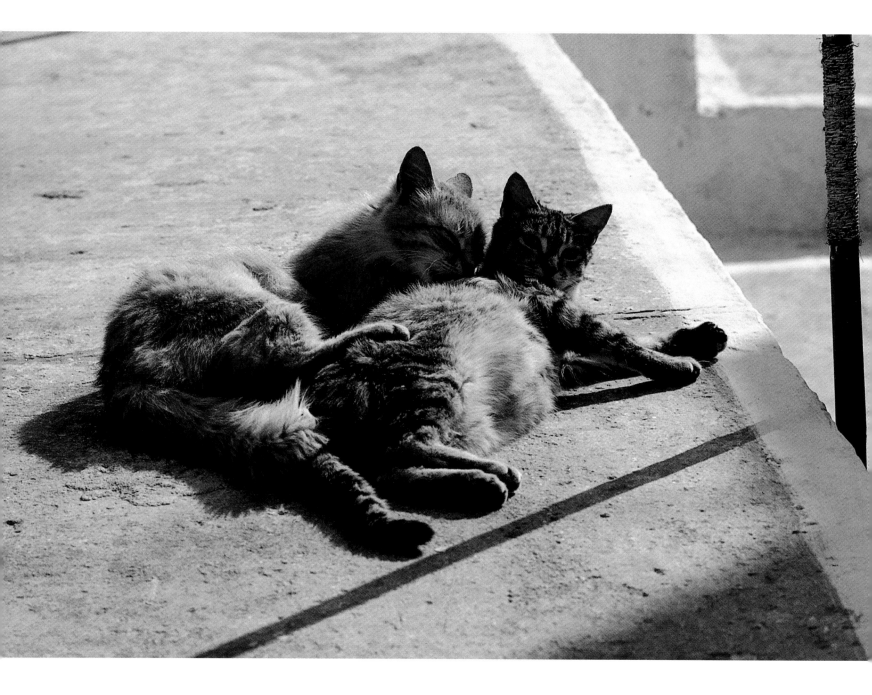

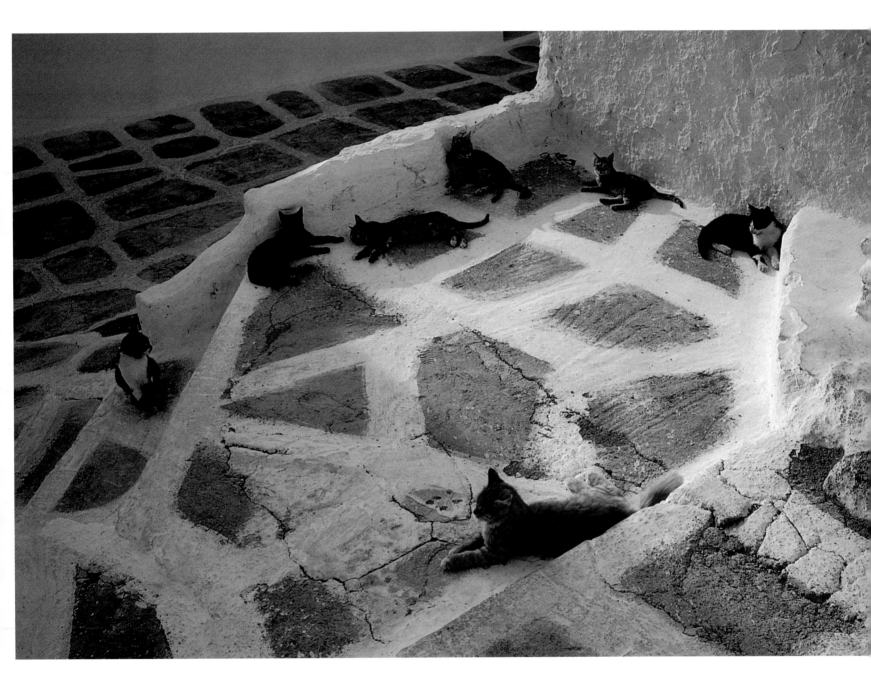

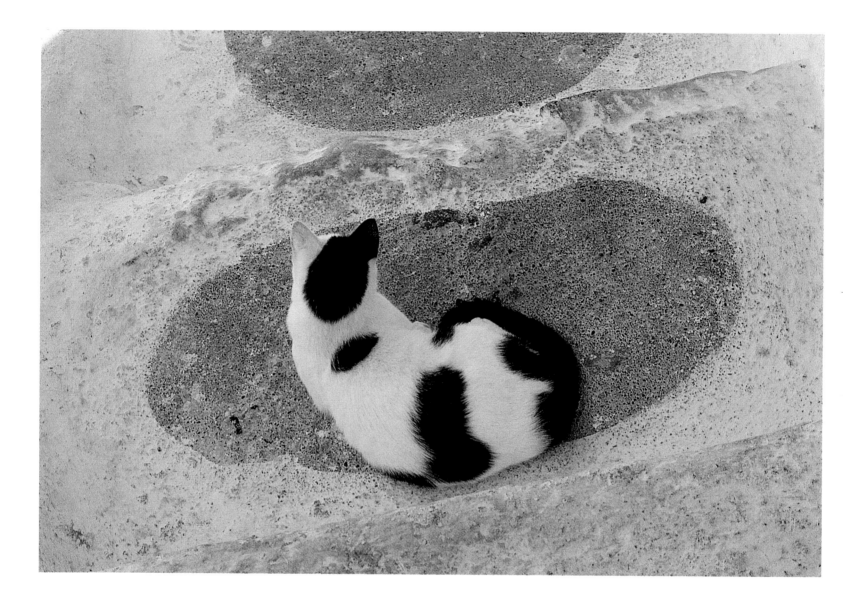

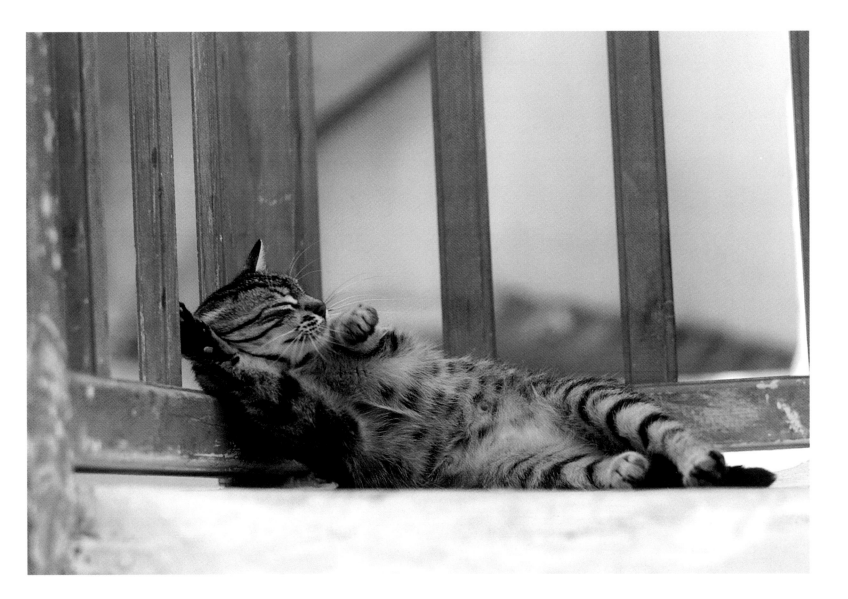

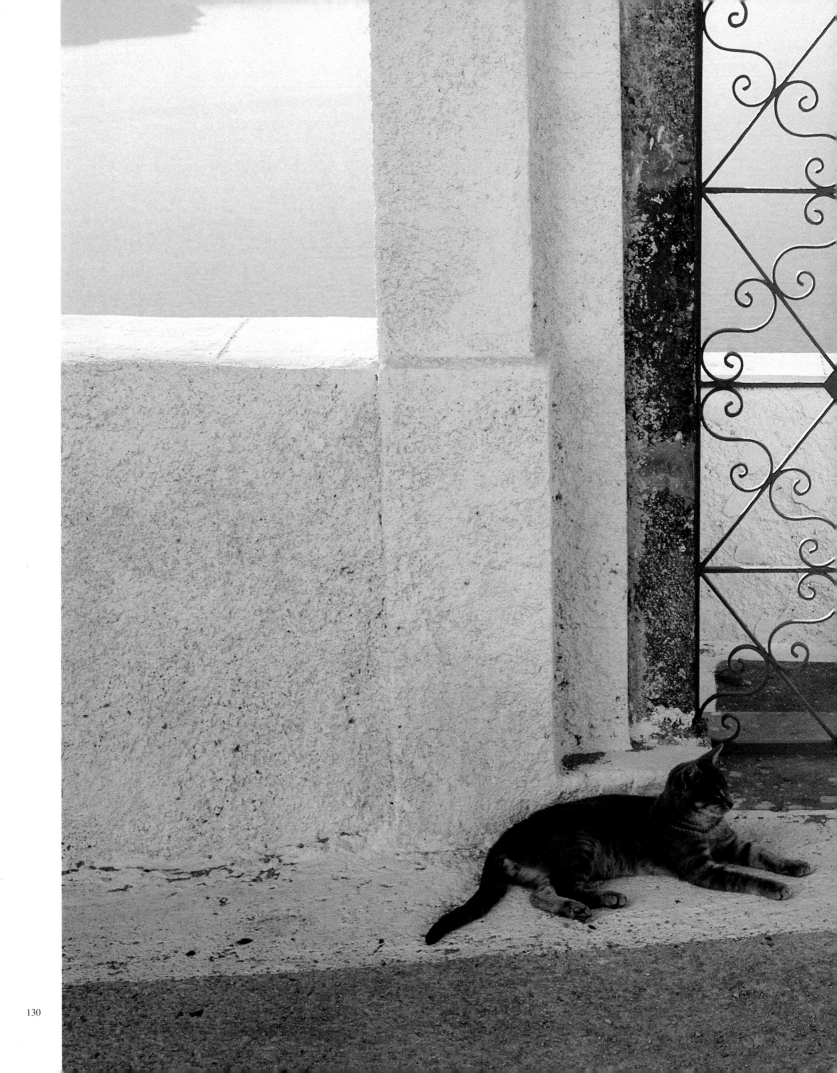

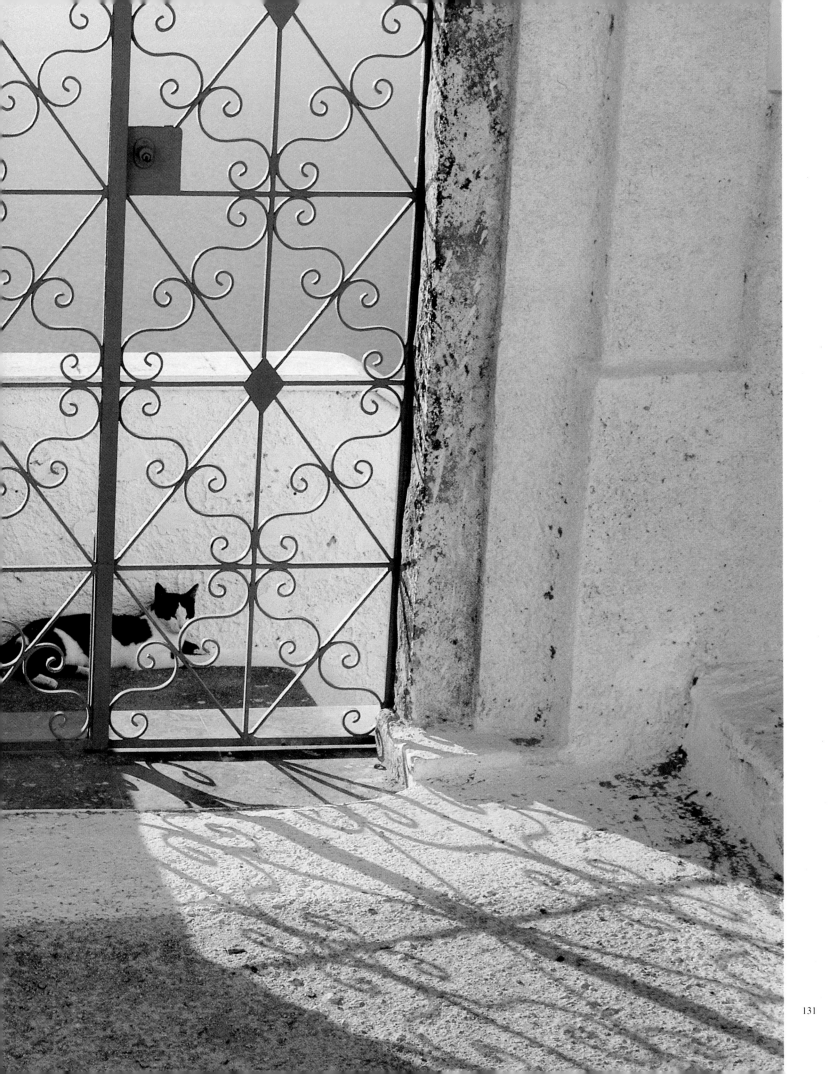

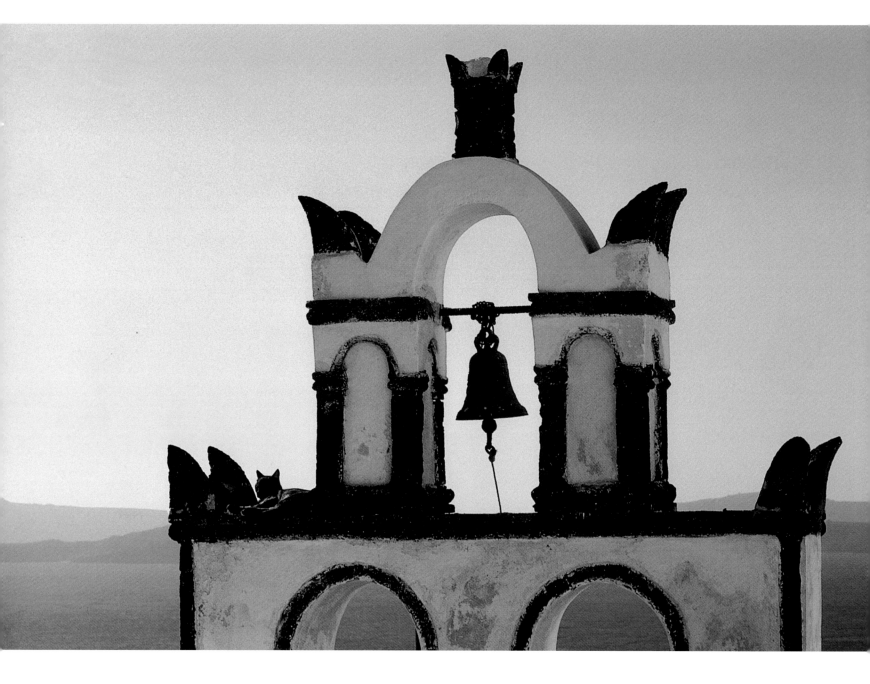

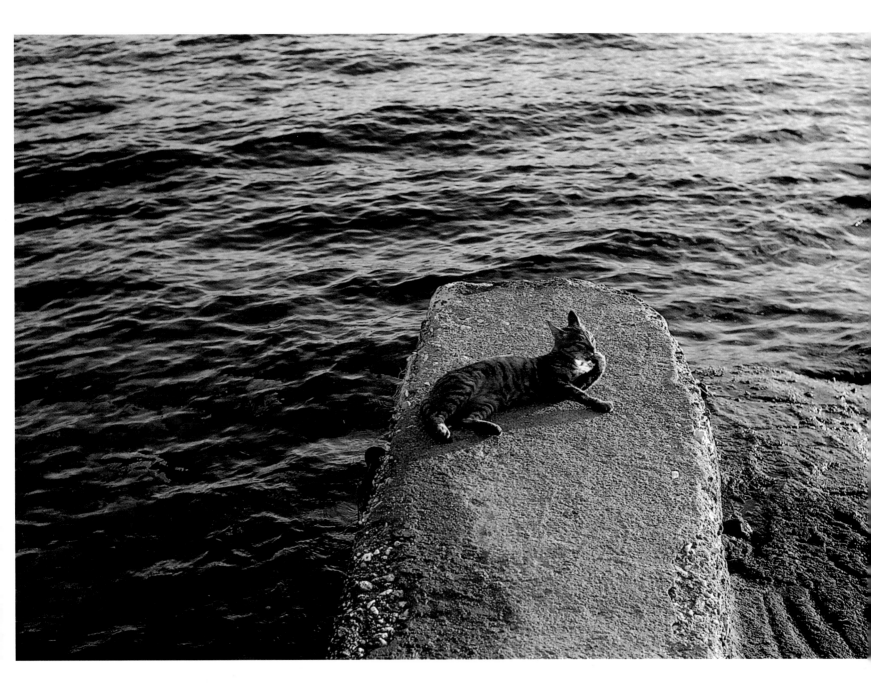

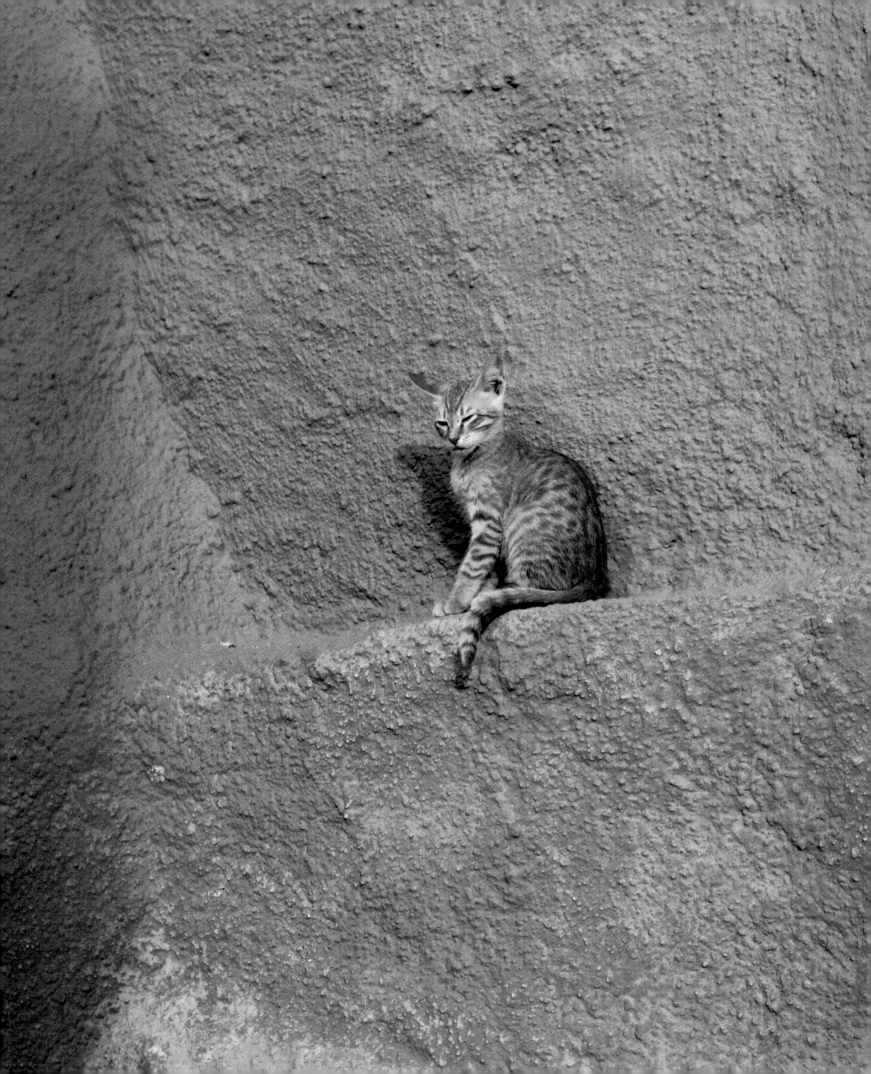

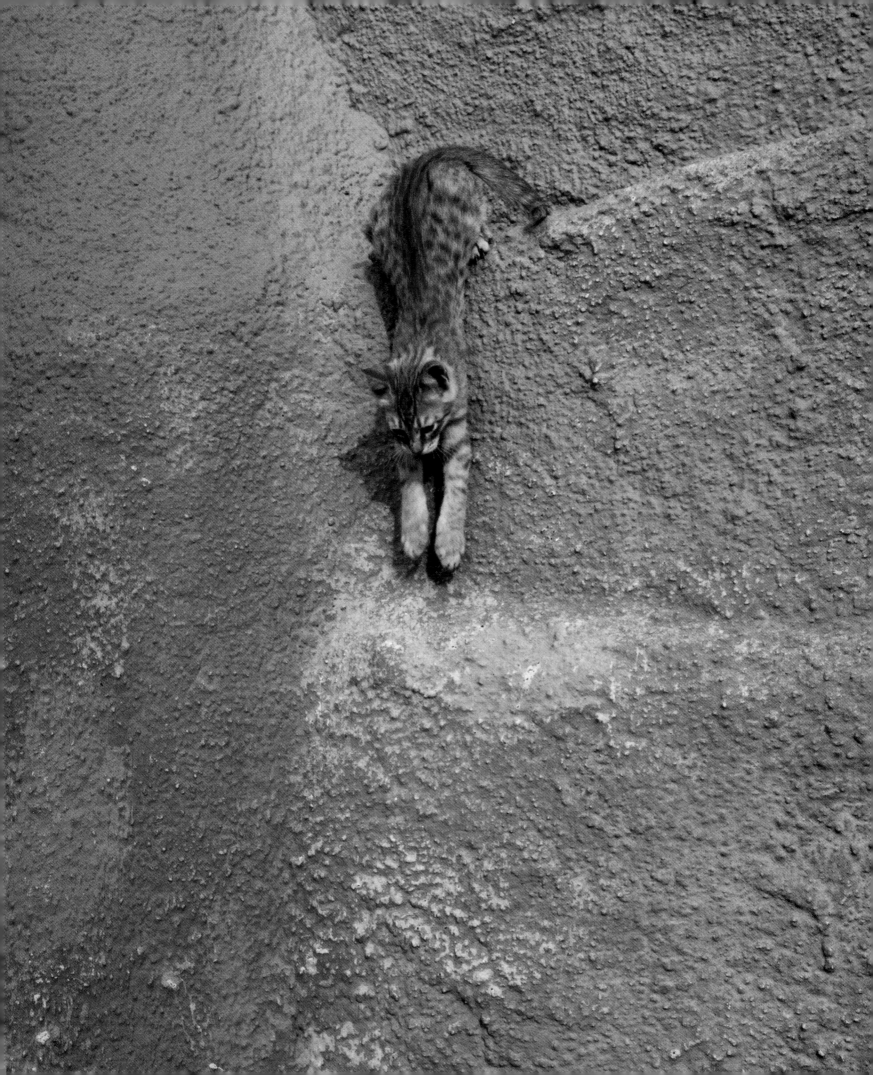

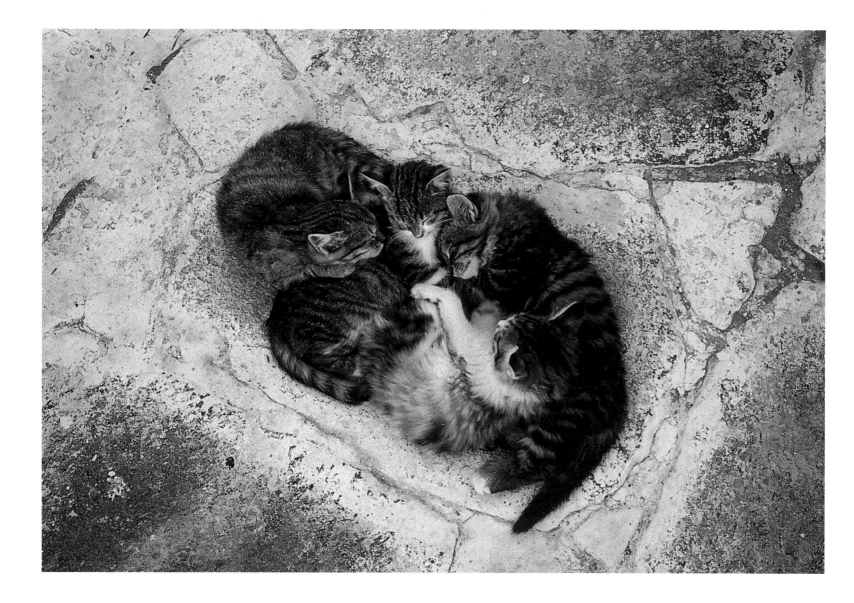

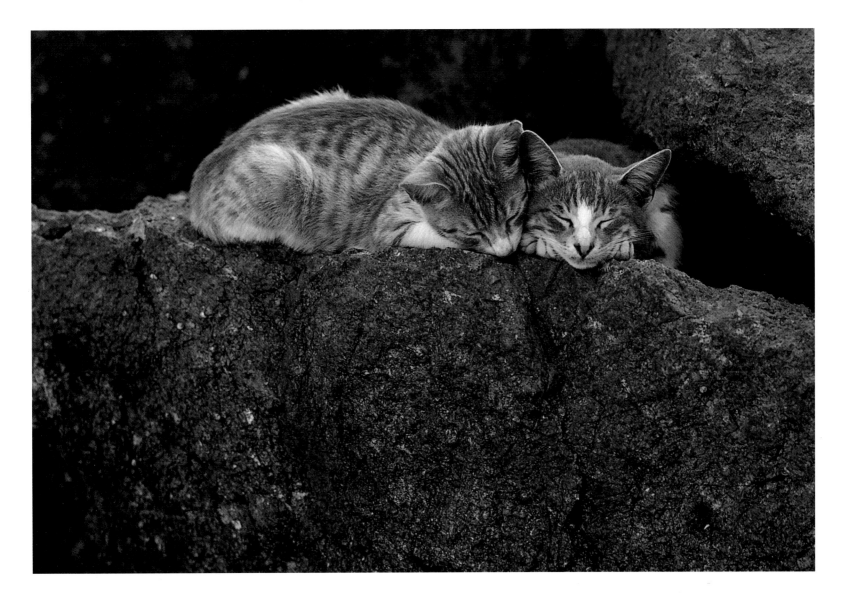

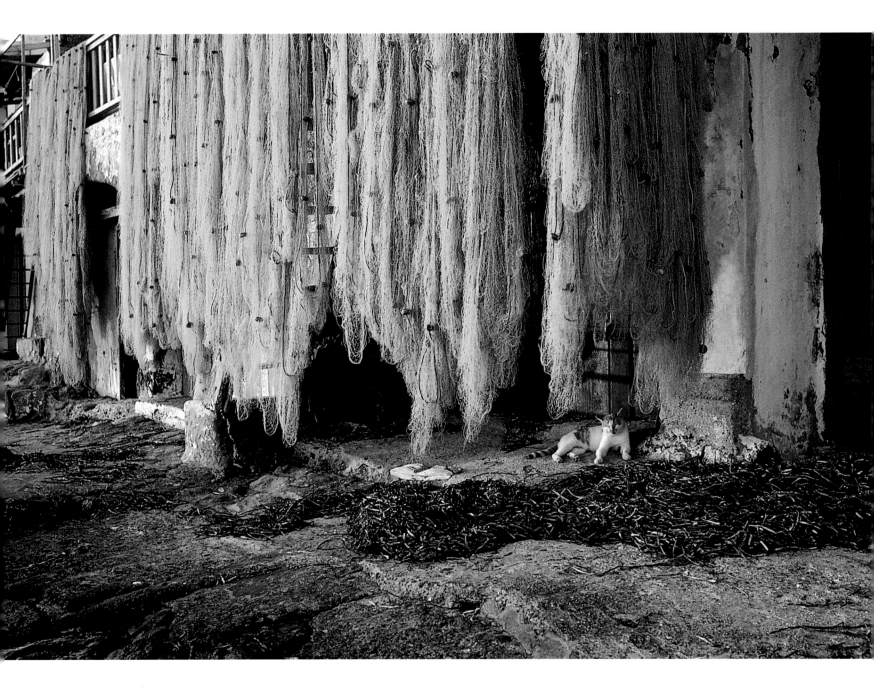

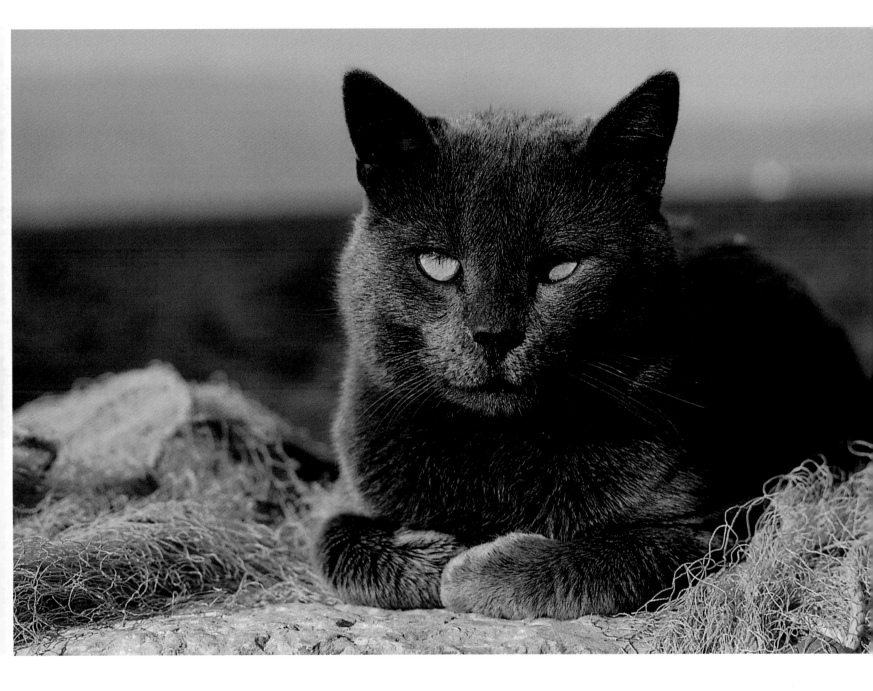

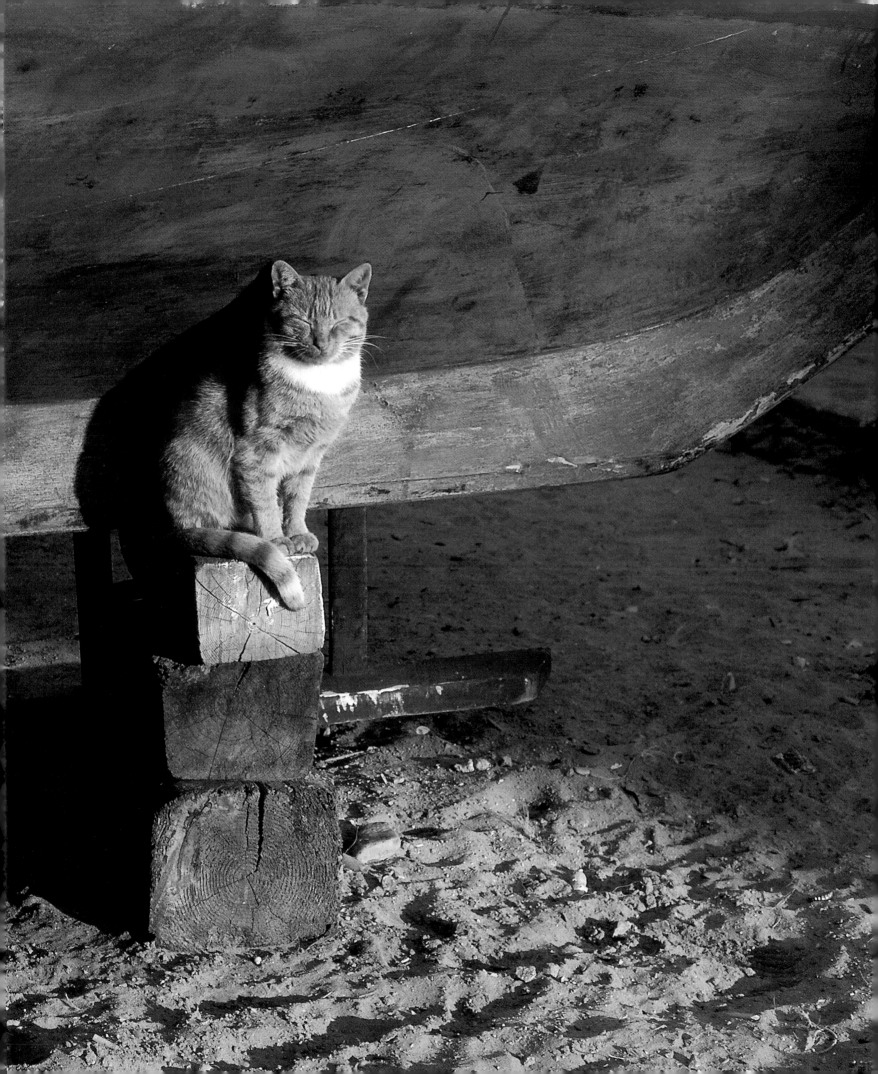

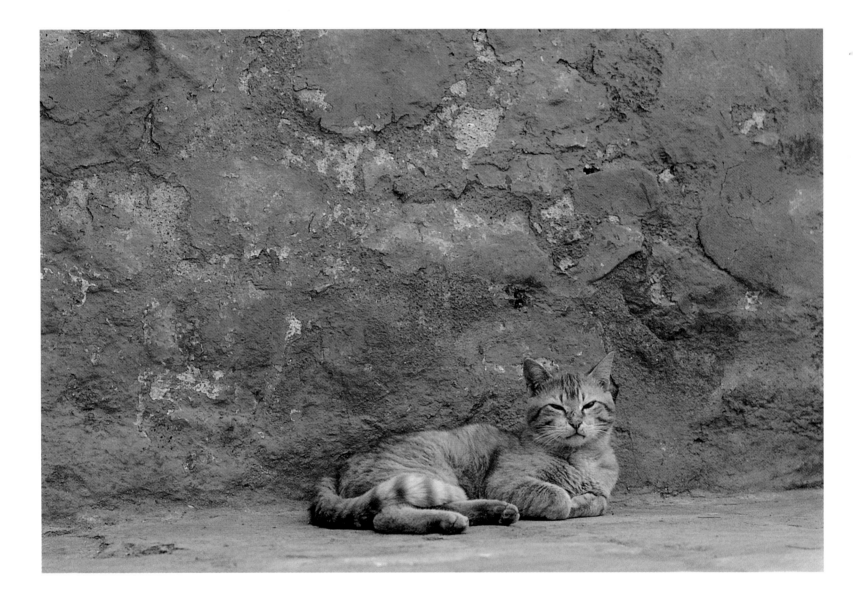